IMAGES
of America

OREGON'S
CAPITOL BUILDINGS

On the Cover: Looking east across Willson Park, this photograph shows the west entrance of the 1876 Oregon capitol building. In addition to Breyman Fountain, a gazebo and bandstand are visible. This building actually faced west. The copper-clad dome and staircases to the second story were added after the initial construction. The structure burned down in 1935. (Oregon State Legislature.)

IMAGES
of America

OREGON'S
CAPITOL BUILDINGS

Tom Fuller

Copyright © 2013 by Tom Fuller
ISBN 978-1-4671-3025-7

Published by Arcadia Publishing
Charleston, South Carolina

Printed in the United States of America

Library of Congress Control Number: 2013931563

For all general information, please contact Arcadia Publishing:
Telephone 843-853-2070
Fax 843-853-0044
E-mail sales@arcadiapublishing.com
For customer service and orders:
Toll-Free 1-888-313-2665

Visit us on the Internet at www.arcadiapublishing.com

To the people of Salem who, through political infighting, budget constraints, fire, water, and earthquake, have managed to care for the capitol building. Their dedication ensured that Oregon's government, and its people, would always have a place to call home.

CONTENTS

Acknowledgments		6
Introduction		7
1.	First Capitols	9
2.	The 1876–1935 Capitol	17
3.	Fire!	35
4.	Rebuilding	59
5.	A New Capitol	89
6.	Willson Park	103
7.	Plans and Modern Building	111
8.	Capitol Events	119
Bibliography		127

ACKNOWLEDGMENTS

The author would like to extend thanks to several individuals who went out of their way to search for, retrieve, scan, or make available the images and information used in this book. The reference librarians at the Oregon State Library were very helpful, especially Dave Hageman. A big thanks goes to Austin Shulz at the Oregon State Archives Division, who tirelessly brought out cart after cart of boxes and helped retrieve images he had found that would be of interest. Bill Sweeny at the Oregon State Legislative Administration was also very helpful in encouraging the project and providing great images.

INTRODUCTION

Though Oregon's three capitol buildings were constructed during contrasting cultural and economic climates, the buildings still reflect common characteristics of the people of the state.

Consider the first building, constructed in 1854–1855 shortly after Congress confirmed Salem as the capital city. At the time, Oregon was still a territory and not yet a state. At a cost of only $40,000, the structure was a sparse two-story wooden affair with a stone facade. The simplicity of the capitol reflected both the pioneer spirit of Spartan existence in an untamed land and the fiscal realities of forming a state government out of nothing. Unfortunately, $40,000 was not enough to complete even this simple building, and construction was stopped. It took another nearly $15,000 to complete the work. Oddly, just prior to completion in January 1855, a bill to move the capital to Corvallis prevailed in the legislature. For a precious two weeks that December, Corvallis enjoyed being the Oregon's territorial capital. The only problem was that the executive officers of the state, including Gov. George Law Curry, refused to move. The renegade legislature met only long enough to vote a move back to Salem. They did this after learning that Congress would not appropriate any money for a capitol building outside of Salem.

In an odd twist of fate, on December 29, 1855, fire broke out in an unfinished area in the northeast part of the building. By the time the blaze was discovered, it was too late and the capitol burned to the ground, along with most of the territorial records. Some at the time suspected the fire was started by those who favored Corvallis as the capital, but no arrests were made.

For the next 20 years, the state government was quartered in the Holman and Nesmith Buildings at Commercial and Ferry Streets in Salem; neither building stands today. Finally, in 1872, the legislature appropriated funds to construct a new capitol. By this time, Oregon had been a state for 14 years, and there was interest in building something much grander than the original wooden structure. Built in the grand Italian Renaissance style, the new capitol was much larger than the first, at three stories high, and was shaped in the form of a cross. Again, funds ran short, and additions to the building had to wait. In 1887–1888, grand staircases and covered porticos supported by Corinthian columns were added. Finally, in 1893, the huge copper-clad dome was set on top of the building. The final cost of this grand capitol was $550,000. The main purpose of the dome was to let light into the rotunda. It soon became the symbol of state government, and many people posed in front of it through the years. But the very means of supporting the massive dome contributed greatly to its destruction.

The eloquent and stately building stood for nearly six decades—facing west, just as the pioneers who settled Oregon faced as they traversed the long and dangerous journey over the Oregon Trail. On the night of April 25, 1935, though, it all changed. Charles M. Charlton answered the phone at the Salem Fire Department shortly after 6:00 p.m. Statehouse janitor Henry Weslowski was calling to say he had smelled smoke and then saw it coming from an elevator shaft on the first floor. In an *Oregon Capitol* article, Charlton remembers thinking at the time, "We never thought too much about there being a serious fire there." Just in case, the Salem Fire Department sent all five of its

7

bright red pumper trucks. Ironically, the Great Depression, which the country was in the depths of at the time, contributed to the demise of the building. It caused layoffs at the fire department, hampering a response to the blaze, and Gov. Julius Meier had vetoed a $25,000 appropriation for a safe to protect vital documents in the capitol. He deemed the vault "unnecessary."

By the time Charlton and his team arrived, the smoke was so thick in the basement that they could not enter. It began to ooze from the windows at the base of the dome. The problem was that the blaze, which apparently started in some paper records stored in the messy basement, was drawn up hollow walls and columns all the way into the dome itself. The chimney effect was perfect for transforming a paper fire into a conflagration. As night fell, the fire began erupting from the dome windows and could be seen as far away as Silverton. Crowds gathered to watch the beloved structure succumb to the flames. When, at last, the dome itself crumbled into a heap of twisted metal, it unleashed a barrage of sparks into the night sky that drifted over the Willamette University campus. Charlton was ordered to spray water on the treasurer's office in the northeast wing of the first floor in attempt to save vital state stocks and bonds worth millions of dollars.

By the next morning, not much remained. What had once stood proudly 187 feet in the air was now a shell filled with rubble. Miraculously, when deputy treasurer Fred Paulus entered the building, he found the treasurer's office intact and the vault in good shape. Paulus came up with a plan to replace the capitol by charging a three-year serial levy on the people, with the federal Public Works Administration (PWA) paying 45 percent of the cost. First, though, the state had to decide where to rebuild. The governor wanted to relocate to the south on a location that would provide grand views, but the idea was quickly quashed. In October 1935, the legislature spent 20 days in Salem, where they adopted Paulus's plan but not his idea of continuing to face the capitol to the west.

In a nationwide competition, more than 100 architectural firms vied for the coveted job of designing a new state capitol. Tastes had changed since the 1870s, and funds were short. So, instead of rebuilding a grand capitol, the winning design was less ornate and simpler, perhaps in a return to the plainer days of early territorial government. Newspapers at the time described it this way: "Better is the word individualistic. It will be different than any of the other 47 state capitols in the United States . . . it will be the finest appearing state capitol in this nation of fine and great capitols."

It took from December 4, 1936, to October 1, 1938, to construct the modernistic capitol, built in Art Deco style labeled as a combination of Egyptian simplicity and Greek refinement. To top the structure, the New York designers chose not a dome but something simpler. A July 1936 *American Architect and Architecture* article stated, "Instead of the customary dome, we preferred to express the dignity of the State's Capitol in the form of a monumental mass, simple as the thoughts and actions of the original settlers." The $2.5 million building also suffered from budget constraints, and it was not until 1977 that wings could be added to provide committee meeting rooms and legislative offices.

Topping the new structure, the *Oregon Pioneer*, also known as "Gold Man," a 22-foot-tall gold-gilded statue, holds an axe in one hand and a tarp in another and faces west, ready to continue the pioneer spirit that gave birth to the state of Oregon.

One

FIRST CAPITOLS

The first meeting for any kind of organized government in Oregon took place near the Willamette River on May 2, 1843, when a group of settlers gathered at Champoeg near Newberg and voted 52-50 in favor of becoming a part of the United States of America. A provisional government was created within a few months. Oregon City became the first location where this new government met. The session of 1844 was held at the home of Felix Hathaway. The next year saw three legislative sessions, held in homes, as were sessions in 1846. By 1847, the government met at the Methodist church on Seventh and Main Streets. Finally, on March 3, 1849, the legislature passed a proclamation declaring the Territorial Government of Oregon to be in effect. This began years of fighting to determine where the capitol would be located. The legislature met in Oregon City, Linn City, Salem, and Corvallis until, finally, in 1864 the question was settled: Salem would be the capitol.

Steps to build a capitol building began in Congress during the 1853–1854 session, where funds were appropriated to construct a statehouse for Oregon. Salem pioneer William H. Willson sold block 84 of his donation land claim to the state in order to build the capitol. The $40,000 building was of Greek Revival style and stood 50 feet wide and 75 feet long. It was two stories high and constructed with native Ashlar blocks. Its color ranged from sky blue to white. But construction on the first building was not even complete before the legislature voted to move the capitol to Corvallis. Some officials moved to Corvallis, but Gov. George Law Curry objected to it and appealed to the federal government for help.

Though Salem prevailed as the state capitol, advocacy for Corvallis ran deep; so deep that when the first capitol building caught fire on Sunday, December 30, 1855, it was blamed for a time on arson. No one was arrested, but the rumors persisted.

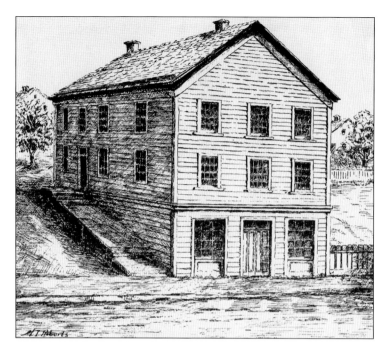

Oregon's first capitol building was not in Salem at all. Prior to statehood, the Oregon Country provisional government named Oregon City as the capital on December 19, 1845. This building, constructed in 1849 by John L. Morrison, served as the capitol for the July 1849 session. It was located at Sixth and Main Streets but was destroyed in 1910. (Oregon State Library.)

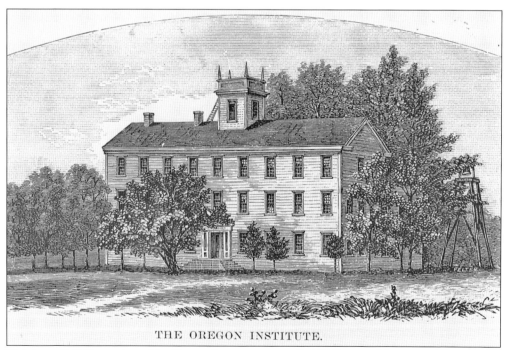

This is an 1842 illustration of the Oregon Institute, now called Willamette University. The institute was born on January 17, 1842, when a group gathered in the home of Salem founder Jason Lee to discuss creating a school for the children of missionary families. The territorial legislature met in the two large front rooms of this building for the 1851–1852 session. (Oregon State Library.)

Joseph "Joe" Lane was selected as the first governor of the Oregon Territory by Pres. James K. Polk. Lane arrived in Oregon on March 3, 1849, after fighting in the Mexican-American War and proclaimed Oregon City as the capital. In 1850, the legislature chose Salem, but then Gov. John Gaines refused to move. (Library of Congress.)

Orville Pratt served as an associate justice on the Oregon Supreme Court from 1848 to 1852. For a time, he was the lone justice on the court. He wrote the only dissenting opinion against keeping the capitol in Oregon City. Congress ultimately decided on Salem as the capital in 1852.

US president Zachary Taylor first offered the governorship of the Oregon Territory to Abraham Lincoln. Lincoln turned him down, so Taylor offered the position to John Gaines. Gaines held office from August 1850 to May 1853. When he tried to keep the capital in Oregon City, he fought as a Whig against a Democratically controlled legislature and lost. (Salem Public Library.)

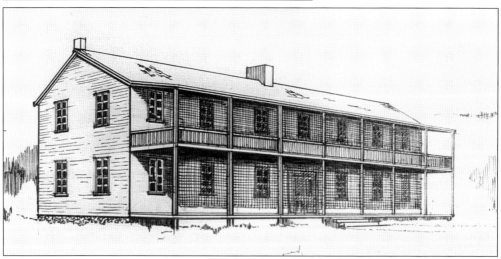

The 1850–1851 meeting of the Oregon Territorial Legislature took place in Linn City at a hotel owned by J.B. Price. During this session, the legislature passed "an act to provide for the selection of places for the location and erection of public buildings of the territory of Oregon." Salem was chosen as the capital city. This building was destroyed in the flood of 1861. (Oregon State Library.)

After 1852, the Oregon House of Representatives met on the bottom floor of the Nesmith-Wilson Building in Salem, located on the corner of Commercial and Ferry Streets. The building was said to hold a printing office and was later home to the *Oregon Statesman* newspaper. At this time, Pres. Millard Fillmore signed a measure making Salem the official capital. (Oregon Legislative Archives.)

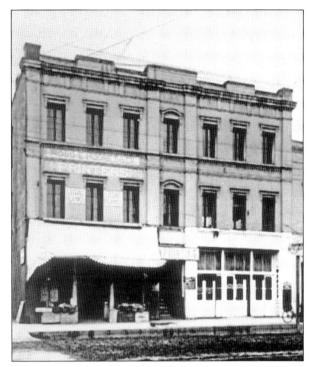

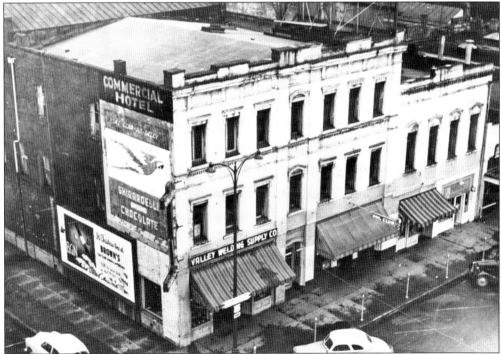

The Holman Building served as a temporary statehouse in 1850. This photograph appears to have been taken in the 1940s or 1950s and shows it to be the home of Valley Welding Supply, the Commercial Hotel, and a club. The building was near a steamboat landing on Front Street. (Oregon State Library.)

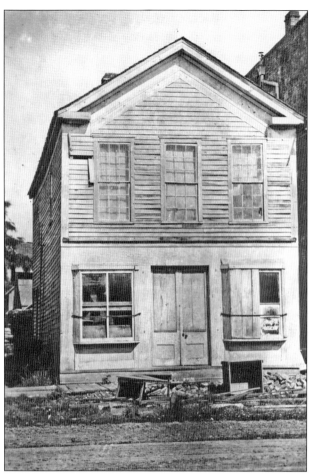

On January 13, 1855, a bill passed the territorial legislature, moving the capital from Salem to Corvallis. The Avery Building served as the temporary statehouse. Gov. George Law Curry objected to the move. In December 1855, the legislature met in the Avery Building just long enough to vote on a bill moving the capital back to Salem. (Oregon State Library.)

In 1854, Congress appropriated money for the erection of a statehouse for Oregon. The building stood unfinished for some time, due in part to a lack of funds and because of the short move to Corvallis. The Oregon Supreme Court did meet in the building despite its unfinished state. (Oregon Legislative Archives.)

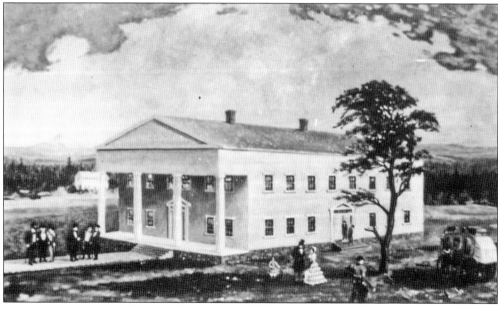

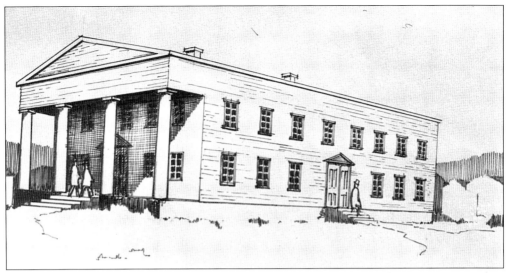

A second view of the Murray Wade territorial capitol shows the building as it appeared in September 1854. That year, the territorial legislature met in the new building, with the House of Representatives on the ground floor. Originally, the entire building was to be constructed of stone, but wood was chosen to save money. (Oregon State Library.)

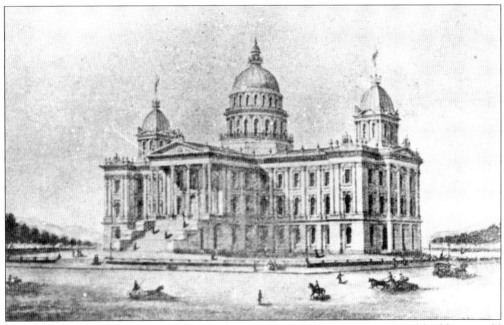

This artist's illustration was one of several proposals for what Oregon's capitol building would look like. It featured a large central dome and two smaller side domes. The drawing was done by Murray Wade, who also painted the image of the 1855 capitol building. This design is much grander than the building that was actually constructed. (Oregon State Library.)

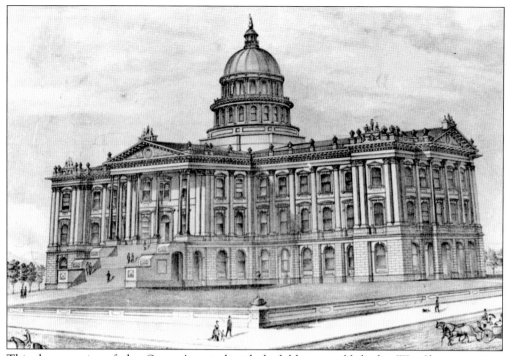

This alternate view of what Oregon's capitol might look like was published in *West Shore* magazine. It more closely resembles the actual capitol that was built in the 1870s. *West Shore* was a literary magazine published in Portland from 1875 to 1891 to promote the image of the Pacific Northwest and encourage economic growth in the region. (Oregon State Library.)

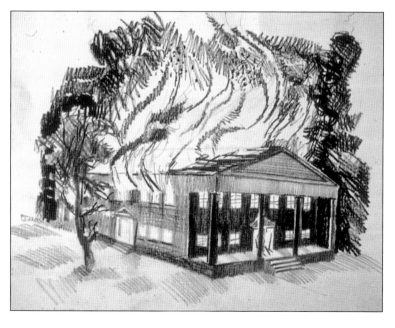

Late during the night of December 29, 1855, a fire broke out in the northeast corner of the capitol building. At the time, arson was suspected but never proven. Many of the Oregon Territory's public records were also destroyed in the blaze. The site remained a pile of stones for several years until a new capitol could be built. (Oregon State Legislature.)

Two

THE 1876–1935 CAPITOL

Though Oregon's first capitol burned to the ground in 1855, it was not until 1872 that the legislature appropriated money to erect a replacement. On February 24, 1873, a Board of State Capitol Commissioners formed. On May 10 of that year, five different plans for the capitol were submitted: three from San Francisco, one from Indianapolis, Indiana, and one from the Krumbein and Gilbert architecture firm of Portland. The board adopted the Portland bid and paid the firm $1,500 for their designs.

The building was constructed on the same plot of land sold to the state by William H. Willson, but Oregon's second capitol was not finished for many years. Pride for the new statehouse brimmed in Salem. In 1880, the *Salem Directory* boasted, "When the elaborate finishing, required by the plans, and the finely shaped and elegant dome shall surmount the already handsome structure, then Oregon and her people will justly feel proud of her State Capitol, and Salem will boast not only the finest county building on the Pacific Coast, but one of the finest state capitols in the Union."

Construction began on the first stage of building in May 1873 and was completed in August 1876 at a cost of $190,927. The cross-shaped building faced west towards the Willamette River. In 1888, porticos were added, along with two-story Corinthian columns at a cost of $100,000. The giant copper-clad dome, which so typifies this capitol, was not added until 1893. All told, the 1876 capitol building cost the state around $450,000.

Even though the building was often remodeled, it could not keep up with the growing state government. Until 1914, the capitol housed all the branches of government. That year, the Supreme Court moved to its own building, and numerous other public buildings were constructed.

Gov. Stephen F. Chadwick laid the cornerstone for the capitol on October 5, 1873, with a speech; he was accompanied by several bands. Five years later, construction was still not complete, and the governor in his "State of the State" address to the legislature said of the unfinished building, "Unless something is done to protect the roof, it is liable to be blown off this winter."

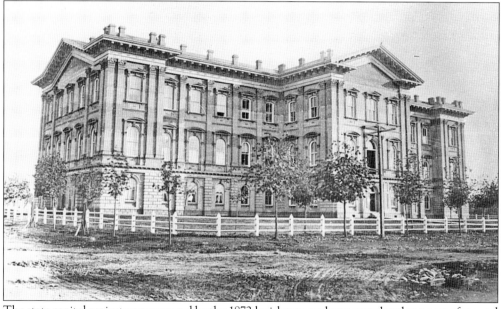

The state capitol project was approved by the 1872 legislature and was completed at a cost of around $325,000. A total of 83 items were placed in the cornerstone, including Oregon's constitution. The building faced west towards the Willamette River. The white fence around the building was designed to keep out stray animals. (Oregon State Library.)

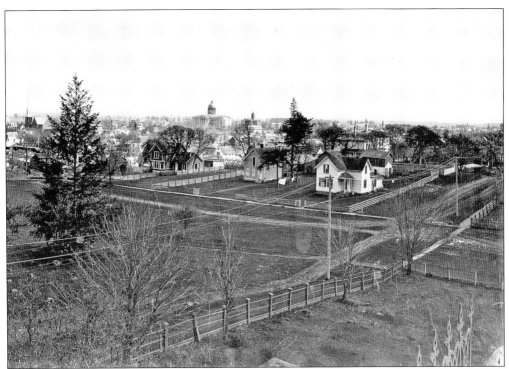
The state capitol building stands in the far background of this photograph, taken sometime between 1893 and 1910. Much of Salem was still very rural at that time. The image was captured from the outskirts of Salem, but the vantage point is just a short distance to the southwest of the capitol. (Oregon State Library.)

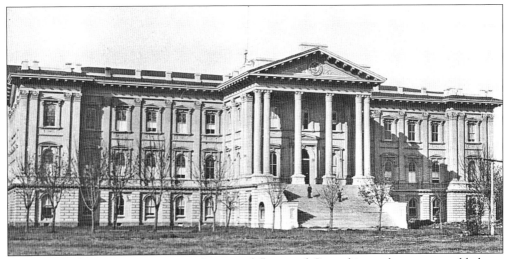
In 1888, the front porticos, stairs to the second floor, and Corinthian columns were added at a cost of $100,000. This is a view of the capitol building taken prior to the installation of the dome in 1893. Until 1914, this building housed all branches of state government, including the Supreme Court and the state library. (Oregon State Library.)

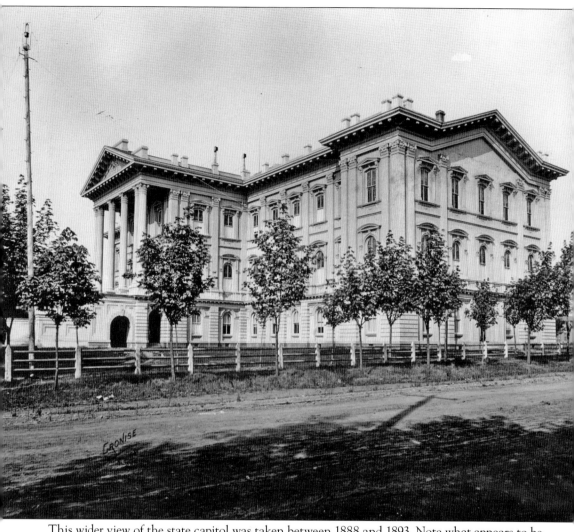

This wider view of the state capitol was taken between 1888 and 1893. Note what appears to be telegraph wires on the left side. Excavation of the building site was performed by inmate labor from the state penitentiary. Waterpower from the penitentiary was also used to cut the lumber for the building. The senate occupied the second floor of the north wing, and the house chamber was above on the third floor. Every arm of state government had offices in the capitol, with room to spare. The basement was practically unused at this time. Among the agencies housed were the department of state police, the Oregon Liquor Control Commission, state land board, commissioner of labor, state parks division, and the secretary of state. It was during this time that the dome was designed. Walter Pugh, the state architect under Gov. Sylvester Penoyer, designed many state institutions, including the copper-clad dome of the capitol. (Salem Public Library.)

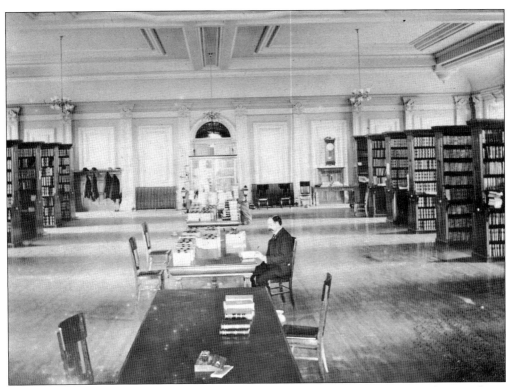

The Oregon State Law Library measured 75 feet by 70 feet. A gentleman in this photograph sits reading at one of the central reference tables. In 1914, the library moved into the new Oregon Supreme Court Building. Many of the volumes pictured here were damaged in the 1935 capitol fire, when water poured on the blaze travelled by underground tunnel to the basement of the structure. (Oregon State Archives.)

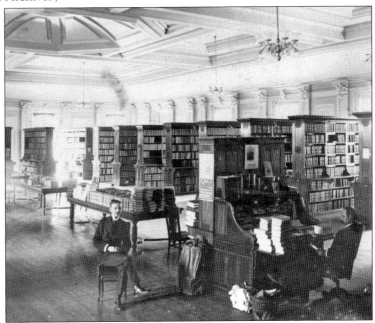

The Oregon State Law Library shared space in the capitol building. In 1877, it had the largest collection of books of any library in the state at 5,257 volumes. The library contained mostly law books, and its primary purpose was as a reference for the judicial and legislative branches. Here, two men pose in front of a reference table filled with volumes. (Oregon State Archives.)

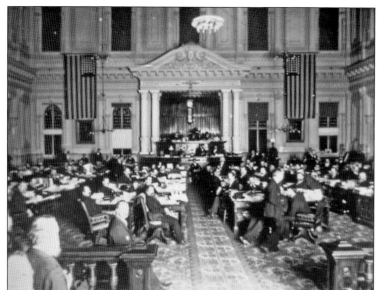

This is one of the very rare photographs of the Oregon State Senate meeting in the 1876 capitol building. This was during the 1895 session. The man in the foreground facing the camera on the left is J.D. Irvine, who was elected as the Senate's doorkeeper on January 15, 1895. (Oregon State Legislature.)

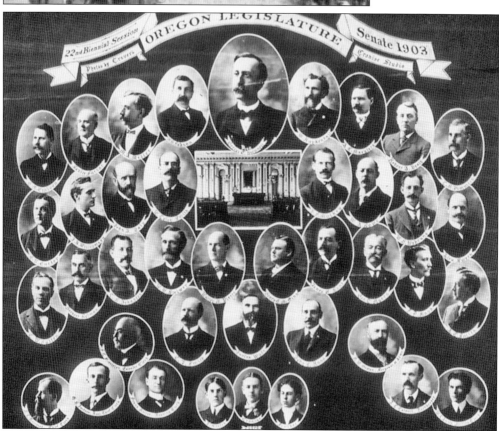

Seen here are the members of the 22nd biennial session of the Oregon State Senate as they appeared in the official senate portrait. George C. Brownell served as senate president for the 1903 session, held in the 1876 capitol (center top portrait). Brownell was a Republican from Clackamas, Oregon. (Oregon State Legislature.)

22

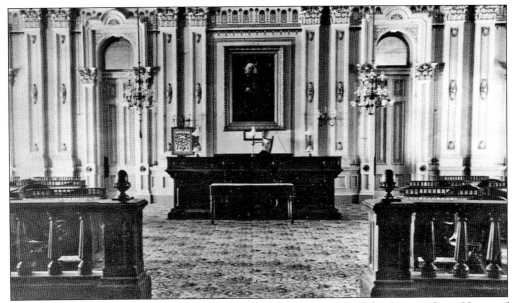

A painting of Dr. John McLoughlin hangs behind the front desk of the Oregon State House of Representatives chamber. Dr. McLoughlin was instrumental in helping pioneers arriving on the Oregon Trail. The photograph appears to have been taken prior to 1920. To the left of the desk, there appears to be a photograph of the senate and house membership. (Oregon State Library.)

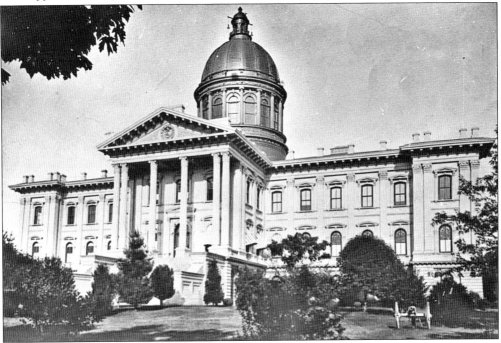

The sandstone used for the capitol building was quarried at Oakland, Oregon, near Roseburg. The State Capitol Building Commissioners reported that the stone was so good it withstood "four thousand six hundred pounds crushing weight to the cubic inch." The state paid $1.85 per square foot for the stone, which the commissioners bragged would "eventually supply this whole coast in this class of building material." (Oregon State Library.)

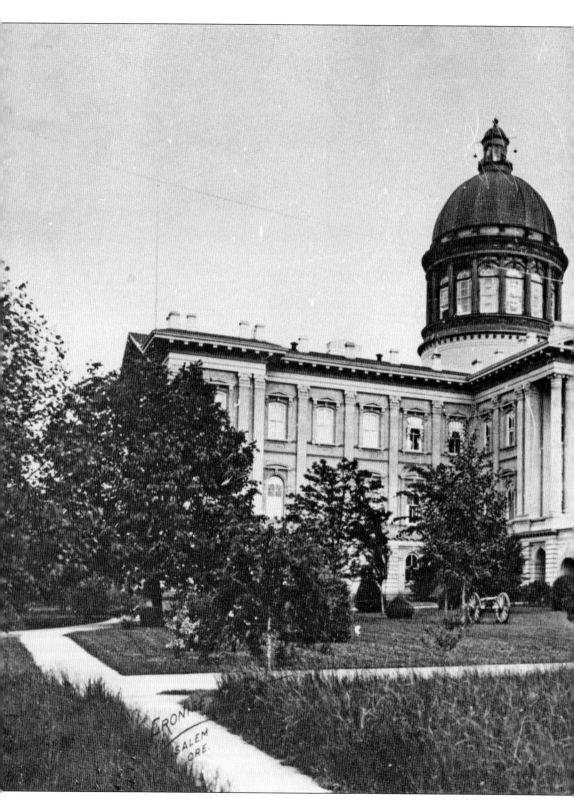

One of the interesting features of this photograph is the addition of sidewalks around the capitol and a cannon that stands on the grass just to the left of the staircase. This was just one of three artillery pieces displayed on the capitol grounds. Due to the size of the trees, this image was likely taken not long after the dome was constructed in 1893. The building was modeled somewhat after the US Capitol. Until 1914, this building held all of Oregon's government offices. The Supreme Court Building also held the Oregon State Library until its home was constructed in 1938. (Salem Public Library.)

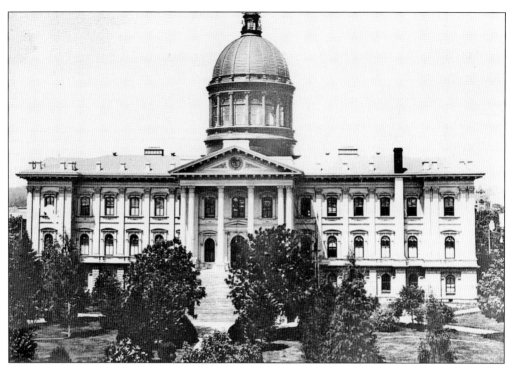

The first floor of the 1876 capitol building was partially underground. The building housed all state departments as well as the legislature and library, including two rooms for the executive branch, two for the secretary of state, one for the state treasurer, one for the school commissioner, and three committee rooms. (Oregon State Library.)

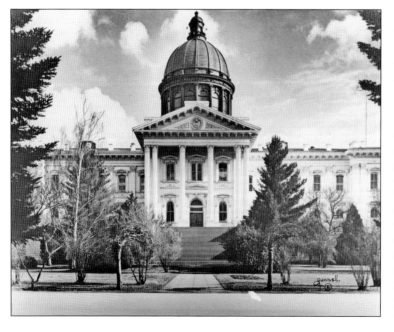

Those who built the 1876 capitol building were intent on the structure lasting for many years. In their 1874 report to the legislature, the Capitol Building Commissioners stated that although the building was "honestly and economically built" that it should also be "solid and substantial, calculated to last for ages." Sadly, it lasted only 59 years. (Salem Public Library.)

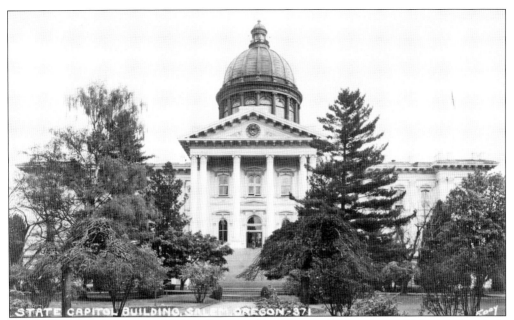

The copper-clad dome was added to the capitol building in 1893 and rose 54 feet in the air. It was constructed with an iron and steel framework. The finished capitol was patterned after the capitol of the United States. The building measured 275 feet by 136 feet and was designed in the Renaissance style. (Oregon State Archives.)

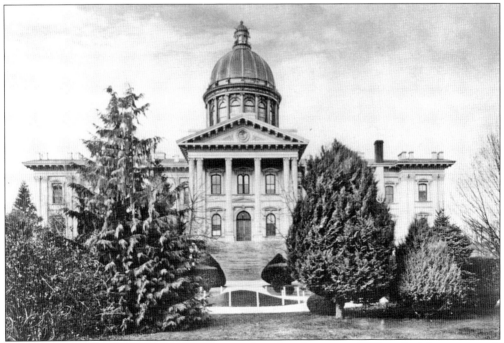

This photograph was taken in 1909, and it is evident that the trees in Willson Park have matured, with sidewalks installed not only around the building, but also on the approaches to the grand staircase. Bushes have also been planted and sculpted in the center. This particular image was taken by Benjamin A. Gifford. (Library of Congress.)

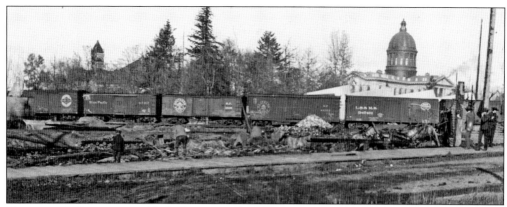

Here is c. 1909 view, most likely facing west, of the eastern portions of the capitol building. A freight train sits on the tracks that run just east of the capitol mall area. The railroad car just under the capitol is most likely from the Lake Shore and Michigan Southern Railway. (Oregon State Library.)

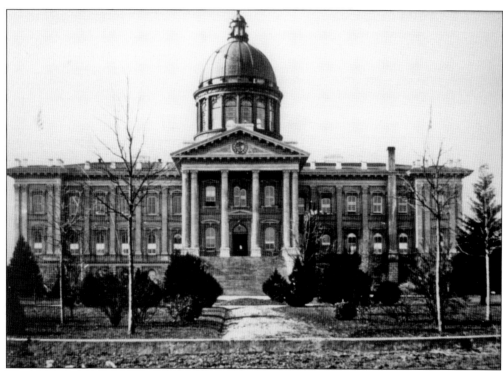

This photograph, featuring the front of the capitol building, was most likely taken shortly after the dome was installed. The dome was held up by hollow columns, which actually helped the fire of 1935 to spread more quickly. Original plans were for two more domes on each side, but they were scrapped to save money. (Oregon State Legislature.)

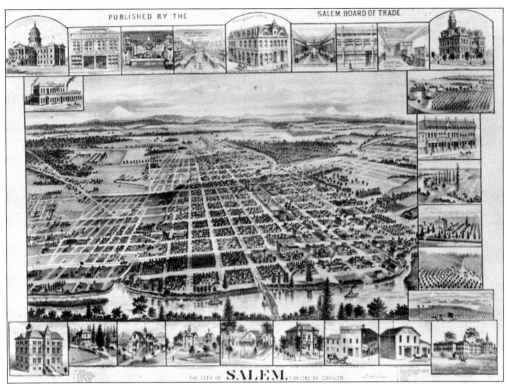

In 1890, the Salem Board of Trade published this map of the city of Salem. It looks from the West Salem hills across the Willamette River. The state capitol building is located in the center right. Several well-known structures are featured along the top and bottom of the map. A drawing of the state capitol appears in the upper left. (Oregon State Legislature.)

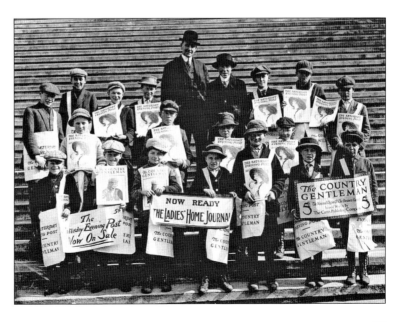

This photograph was taken on February 17, 1913, on the steps of Oregon's second capitol. It features Gov. Oswald West (top center) and a group of 18 newsboys. The boys sold various publications, such as the *Ladies Home Journal*, *Country Gentleman*, and the *Saturday Evening Post*, which sold for 5¢. (Oregon State Library.)

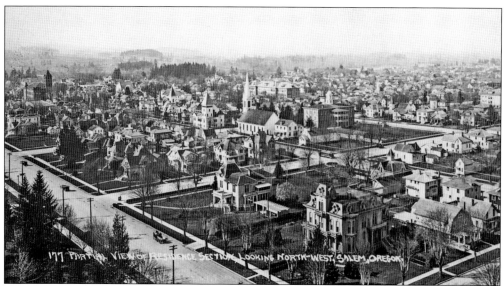

This photograph was taken in 1910 by Ben Maxwell, a well-known Salem photographer. It features a view to the northwest from the 1876 capitol dome. The house in the center foreground was that of Thomas Kay, who started the Kay Woolen Mill. Salem City Hall is in the upper-left corner. (Salem Public Library.)

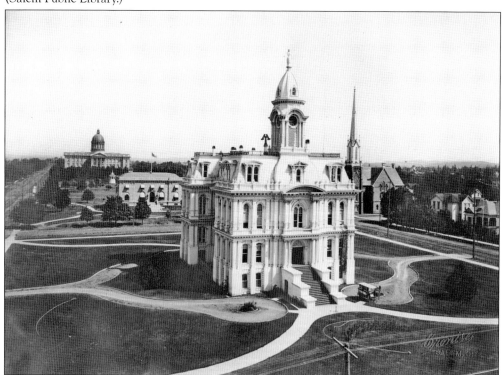

A 1904 image features the Marion County Courthouse, built the same year as the state capitol, seen in the background. The First Methodist Church stands to the right. The courthouse was demolished in 1952, when Salem residents decided it was too expensive to maintain. It was constructed at a cost of between $110,000 and $115,000. (Salem Public Library.)

Oregon's second capitol building was a focal point of early Salem. Edward and Lillian Lamport even had their portrait taken sitting in front of the capitol sometime prior to 1935. Their sons Merrill (left) and Fred joined them in their 1910 Pullman automobile. One interesting thing to note is that Lillian sits behind the wheel. (Salem Public Library.)

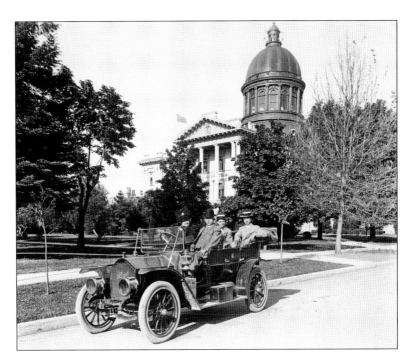

A cannon stands on the grounds of the 1876 capitol around 1930. The inscription on the side-mounted placard details the cannon's caliber (5 inches), the weight of the gun (3,639 pounds), and the weight of the carriage (5,200 pounds). (Oregon State Library.)

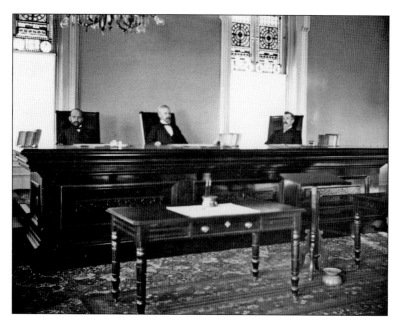

In this rare photograph, the justices of the Oregon Supreme Court pose in the courtroom of the 1876 capitol building. The court was on the third floor and measured 54 feet by 46 feet. It is most likely that the image was taken in 1898 with, from left to right, Justice Thayer, Justice Wolverton, and Justice Moore. (Oregon State Archives.)

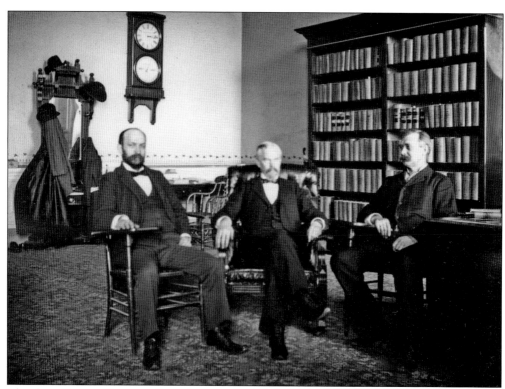

The three Oregon Supreme Court justices sit in chambers in a rare 1898 photograph. The date is likely because this was the only year all three of these justices served at the same time. They are, from left to right, William Wallace Thayer, Charles Wolverton, and Frank Moore. Thayer also served as Oregon governor from 1878 to 1882. (Oregon State Archives.)

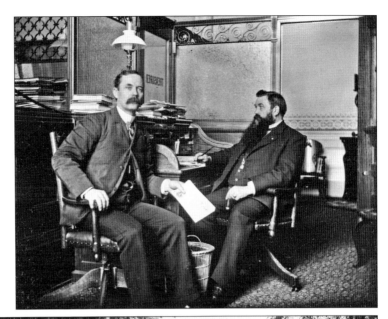

It is known from the word "Treasurer" on the office door that this image was taken inside the treasurer's office in the 1876 state capitol; however, the two men are not identified. The man on the left holds what appears to be a stock certificate or a bond. Many such documents were stored in basement safes and spared in the 1935 capitol fire. (Oregon State Archives.)

This photograph appears to have been taken from east of the capitol building. This portion of Salem had many historic Victorian-era homes of prominent Salem residents. Driving on the street is a 1920s-era automobile passing a horse-drawn carriage. Note that the home in the left foreground has a large covered front porch. Salem saw its first automobile in 1902, which led to paving many city streets, starting with Court Street in 1907. The 1920s was a time of rapid growth in Salem, which was nicknamed "the cherry city." The 1920s also saw the start of the pulp paper industry, the first street car, and the beginning of the municipal fire department. Nearly all of these Victorian-era houses were moved or torn down to make room for more buildings in the expanding capitol mall. Some homeowners took the state to court to fight the evictions. The legislation that authorized the building of the third capitol gave broad rights to the state to purchase or condemn property around the mall. (Salem Public Library.)

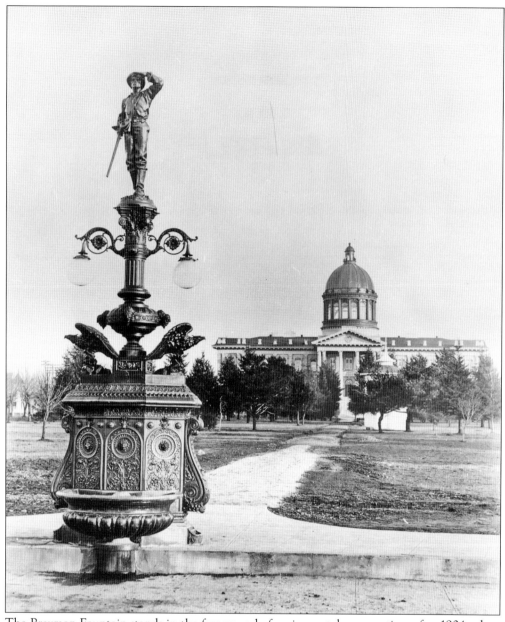

The Breyman Fountain stands in the foreground of an image taken sometime after 1904, when the Breyman family donated the fountain to the city. The fountain was in honor of Werner and Eugene Breyman, both well-known businessmen in Salem. It is the only remaining historical object of its kind in Willson Park. (Salem Public Library.)

Three

FIRE!

At precisely 6:43 p.m. on April 25, 1935, a custodial engineer called the Salem Fire Department to report smoke coming from an elevator shaft of the 59-year-old state capitol building. The fire apparently started where some papers were stored in the basement, and the flames rose rapidly up the elevator shaft to engulf the entire structure. Firefighters from all over the valley rushed to the scene, but the flames had already reached the east roof and the dome, with its copper sheeting crumpling and collapsing on the rest of the building. A north wind spread sparks from the fire to nearby Willamette University, where college students protected campus buildings with fire hoses. One Willamette student, Floyd McMullen, died fighting the fire when the northwest cornice fell on him, fracturing his skull and crushing his pelvis. Among those helping was 12-year-old Mark Hatfield, a future Oregon governor and US senator.

The Salem Fire Department sent seven fire trucks to the scene; three more arrived from Portland. During the blaze, crews poured water over fireproof vaults in the basement that contained more than $1 million in stocks and bonds, which were thankfully spared. News of the fire spread as quickly as the flames. One estimate put the crowd equal to the population of Salem (27,000). People drove in from surrounding communities as the flames in the night sky could be seen as far away as Silverton and Woodburn.

Within hours, the capitol was destroyed and was a total loss. The state carried no insurance on the building, valued at $2 million. Most of the items in the building were lost, including oil paintings of all of Oregon's governors as well as Salem founder Jason Lee and Dr. John McLoughlin. Crowds gathered, with some trying valiantly to pull records and furniture from the burning structure. A desk probably used in the department of corrections was pulled from the flames and now sits in the office of the speaker. Clerks spent the day after the fire sorting through the saved records and file cabinets.

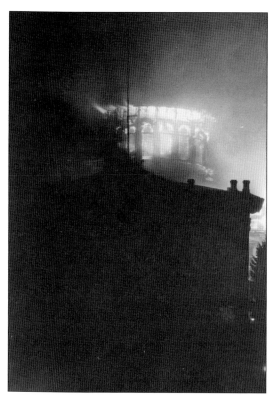

Flames begin to lick the edges of the state capitol dome in a photograph most likely taken from a home near the building. Citizens who began to gather around the fire did not at first know the seriousness of the blaze, but according to fire officials, by the time crews arrived it was already too late to save the historic building. (Oregon State Library.)

Here, the smoke is already coming out of the copper dome of the capitol. The original report was of smoke coming from an elevator shaft. Soon, an effort began to save important records and furniture from the building—an effort that was nearly fruitless. (Oregon State Library.)

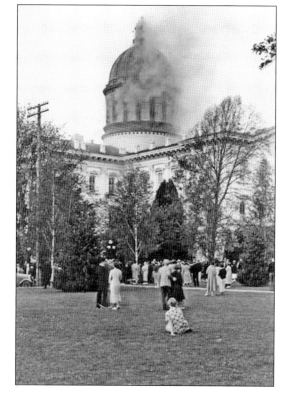

In the span of just a few short minutes, smoke began pouring from the building and out the top of the dome. Here, the flames begin to erupt from near the base of the dome. Fire crews from as far away as Portland began responding to the blaze. (Oregon State Archives.)

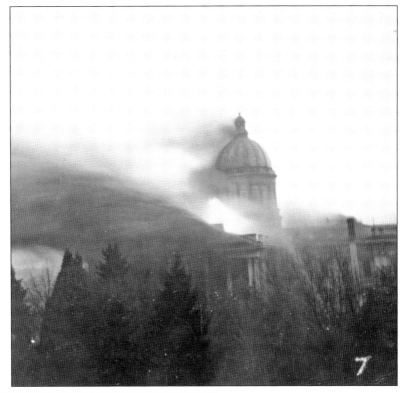

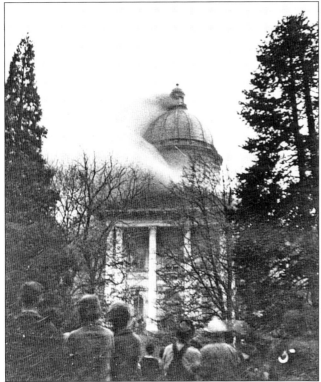

The fire of the capitol became quite the attraction for nearby residents, and not long after the fire began the area was crowded with spectators, with State of Oregon officials among them watching their capitol burn. The *Capitol Journal* estimated the crowd at around 27,000. (Oregon State Library.)

37

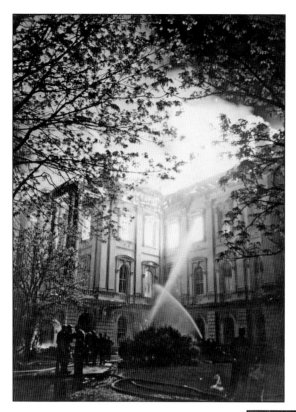

Firefighters poured streams of water on the fire, but it became quickly evident that the structure itself could not be saved, so they concentrated their efforts on preserving important records kept in safes. Three pumper trucks arrived from Portland, and the Salem Fire Department put nearly every piece of equipment it had into fighting the fire. (Oregon State Archives.)

Darkness soon fell on the fire as more firefighters and volunteers arrived on the scene. The blaze soon began to spread into the walls. Firefighters cut holes in floors in order to pour in water and chemicals, but it did not stop the flames from spreading throughout the structure. (Oregon State Archives.)

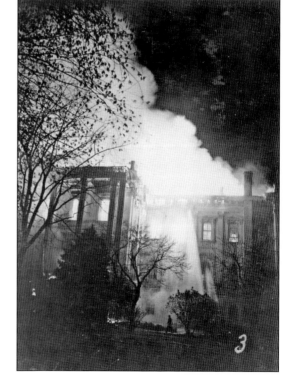

Most activity came to a halt in Salem as the fire illuminated the dark skies. The flames were visible from as far away as Silverton and Woodburn. In this view from downtown, the Any Time Quelle Cafe and the Sears building frame the capitol fire, only blocks away. (Oregon State Archives.)

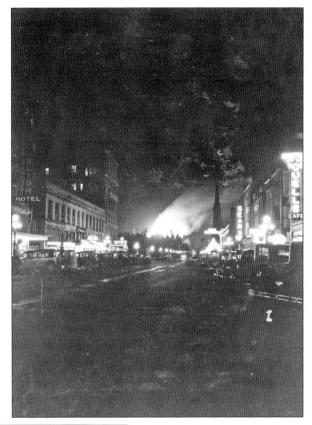

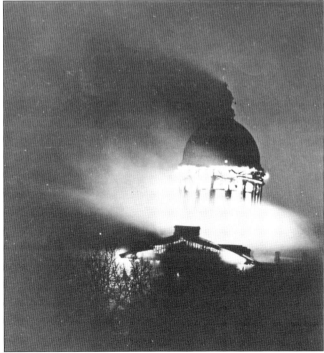

Eventually, the fire spread into the copper dome. Soon after, the dome collapsed when the exterior timbers gave way and the copper sheeting collapsed. The melting and bending of the dome's structure is evident in this photograph, well after the sun had set. When the dome collapsed, it sent up a barrage of sparks into the sky. (Oregon State Library.)

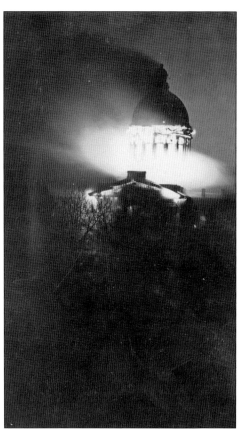

"Fire!" state capitol janitor Henry Weslowski had shouted into the telephone to the Salem Fire Department. No one knows how the fire started in the basement, which was a labyrinth of storage rooms for state records. Air was sucked up through the hollow columns in the main lobby, acting like a chimney, greatly increasing the heat of the fire as it reached the dome. (Oregon State Archives.)

This is probably the most famous photograph of the 1873 capitol fire. It shows the structure completely engulfed in smoke and flames. Flaming pieces of the building have fallen on the front stairs, and the structure above the Corinthian columns is beginning to crumble. (Oregon State Library.)

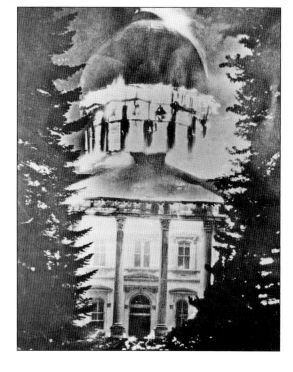

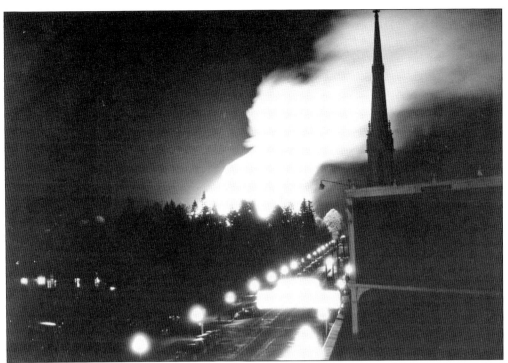

Someone in downtown Salem climbed onto the roof of a building to take this picture, which became one of the most spectacular fires in state history. A north wind threatened to spread the blaze to nearby Willamette University. One of the citizens who helped in the early stages of the blaze was 12-year-old Mark Hatfield, the future governor. (Oregon State Library.)

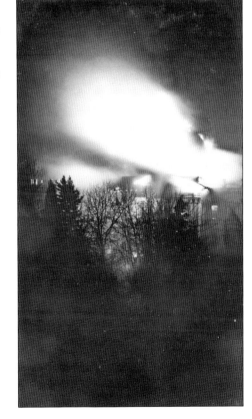

So much smoke and flames came from the capitol that it nearly obscured the building entirely. Shortly before midnight, a cornice from the northwest corner of the building fell on Willamette University sophomore and volunteer firefighter Floyd McMullen. This was the only fatality in the capitol fire. (Oregon State Archives.)

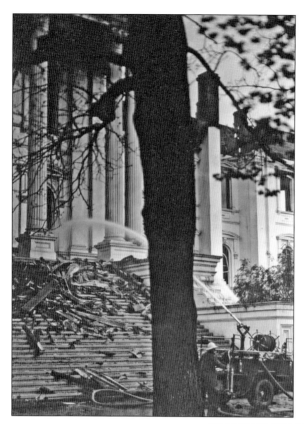

Though the majority of the capitol building burned within hours, some parts of the structure continued to cause concern for firefighters. This photograph was taken the next morning and shows a firefighter standing next to his pumper truck, which is pouring water on the front steps. (Oregon State Library.)

By the morning of April 26, firemen were still on the scene. The men seen here on the far left appear to be hosing down trees and shrubbery. Note that behind them two people sit on their bicycles, looking at the firefighters and the results of the intense blaze. (Oregon State Library.)

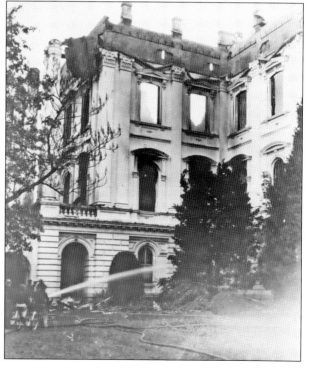

Within hours, the 59-year-old capitol was reduced to ruins. Morning light revealed the outer skeleton of the building with nothing but rubble inside. Here, the columns that once welcomed visitors and statesmen alike hold up nothing but air. The dome, which once graced the skies of Salem, is completely gone. (Oregon State Archives.)

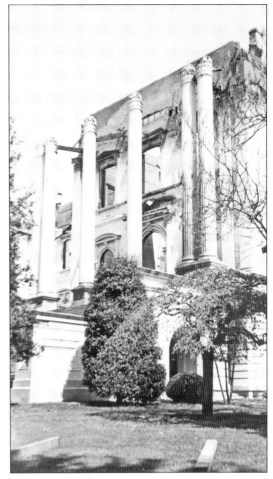

This is all that remained of the copper dome that once stood atop the state capitol building. At 8:04 p.m., the dome, glowing with the green flame of burning copper, collapsed, rolling over with a great crash and leaving behind nothing but twisted metal framing. (Oregon State Archives.)

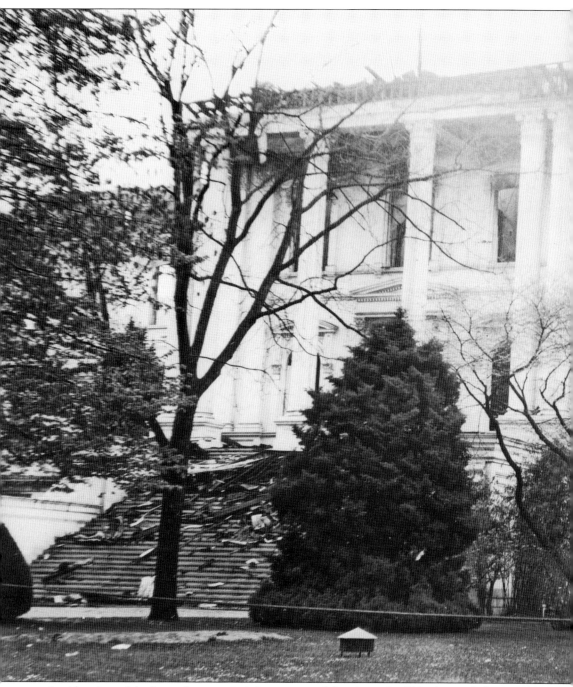

A wider view of the burned-out capitol shows some of the charred rubble that ended up on the grand staircase leading up to the entrance on the west side. Through the windows to the right is the bare brick of what remained. A rope stretches across the frame, holding back the public so state officials could assess the damage. Among those officials was deputy treasurer Fred H. Paulus. He arrived soon after learning of the fire and managed to retrieve his law books,

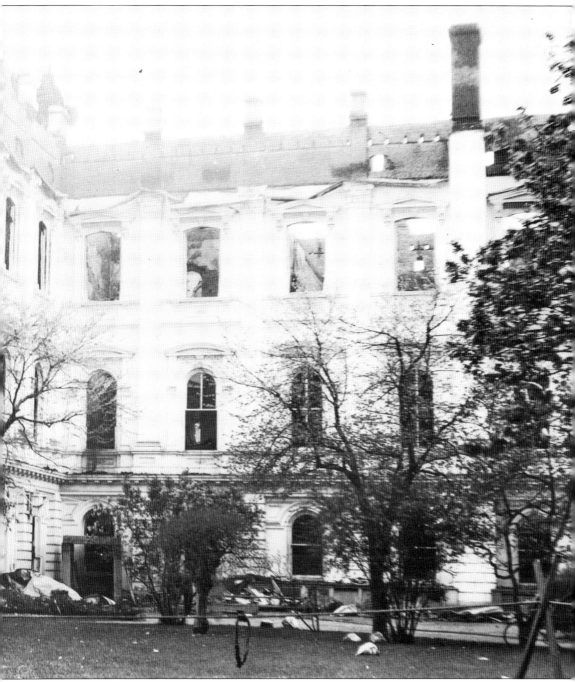
which he took across the street to the Charles K. Spaulding residence on Court Street. Paulus never got the books back, but he did manage to save many important papers. He also directed firefighters to focus their water hoses during the blaze on safes that contained many valuable state documents. (Oregon State Archives.)

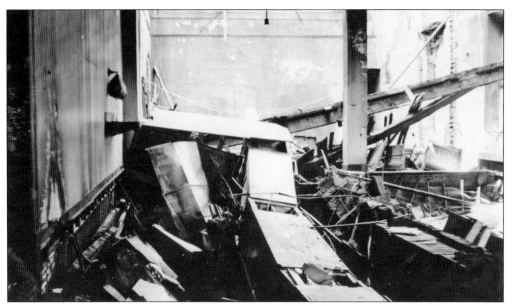

In the first interior view of the ruined capitol, it is difficult to tell up from down. Two windows stand to the right near a charred beam that has collapsed. Nothing was saved from the second and third floors, including invaluable paintings of Oregon's governors and Dr. John McLoughlin. (Oregon State Archives.)

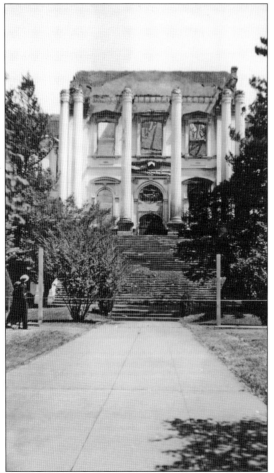

A curious citizen peers up at the main entrance to the capitol, with its massive dome now missing. The state had no insurance on the building, which was a total loss at $2 million ($33.5 million in 2012). The days after the fire were spent trying to recover anything, especially important records, which survived. (Oregon State Archives.)

Three men stand at the base of the staircase shortly after the fire. The columns silhouetted by cloudy skies are no longer a part of the structure. Some of the trees and bushes that were unharmed were later relocated when the capitol was rebuilt. (Oregon State Archives.)

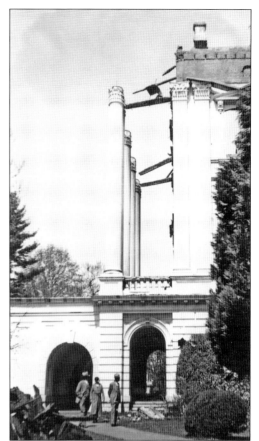

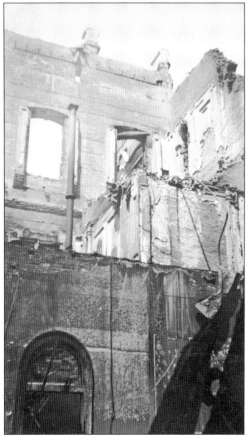

The 1876 capitol building was composed of over five million bricks. Here, in the upper right, some of the brickwork is exposed and broken. Below is what is left of wallpaper. In the center of the frame stands a single steel pole, no longer supporting any part of the structure. (Oregon State Archives.)

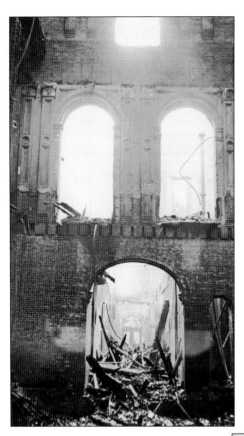

The fire burned so hot that the upper interior floors collapsed and fell on the floors below. This view from inside the building shows two windows and an archway filled with debris. In the background are the remains of a wooden door. (Oregon State Archives.)

Some records did survive the fire. A few of them were placed into the state archives, including this letter dated June 26, 1905. It accompanies a check that appears to have been left blank for the state treasurer to fill in. It was signed by James King of Fossil, Oregon. (Oregon State Archives.)

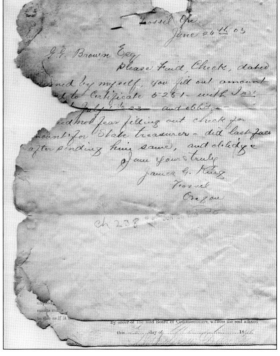

48

These canceled checks still retain the smell of burned paper after more than 70 years since the capitol fire. One check is to the State Accident Commission in the amount of $12.73, while another is to the Public Affairs Information Service for $15. The checks were written in the 1920s. (Oregon State Archives.)

The loss in the capitol fire could have been much worse had the state not used fireproof safes in the basement. Firefighters doused the safes with extensive amounts of water; so much so, that it seeped into the adjoining Supreme Court Building. When officials pulled the safes from the wreckage of the building, they were charred but not destroyed. (Oregon State Archives.)

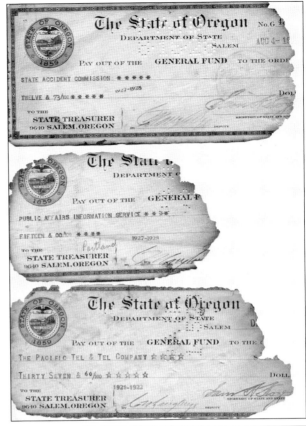

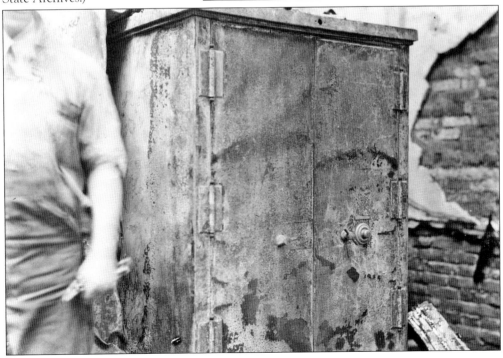

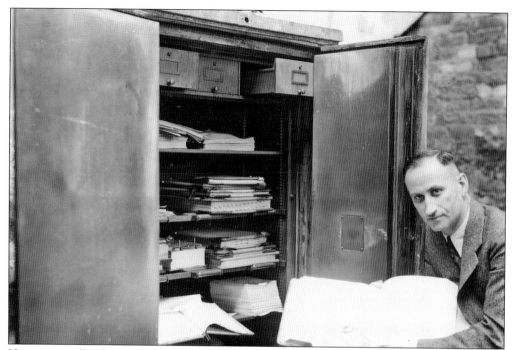
Here, a state official shows off the contents of one of the safes. Inside, the papers and valuables appear unharmed. State officials were able to retrieve more than $1 million in stocks and bonds. The water applied to the safe kept it cool so the contents did not disintegrate. (Oregon State Archives.)

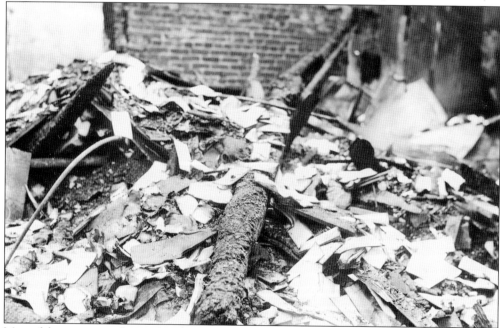
Most of the paper records stored in the capitol building were completely destroyed. This photograph shows some of the paper debris left over from the blaze. Though it has never been determined how the fire began, it is likely that its rapid initial spread was due to the volumes of paper stored in boxes in the basement. (Oregon State Archives.)

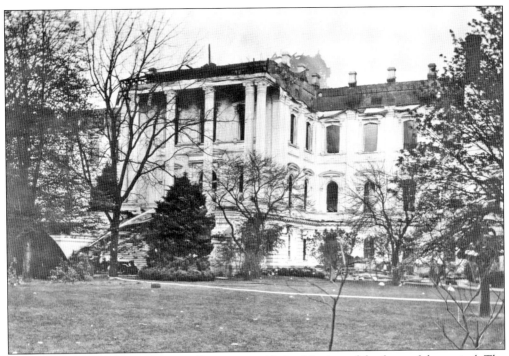

The remains of the dome after its collapse are visible in this view of the front of the capitol. The morning after the fire, the Salem Chamber of Commerce met to help find temporary offices downtown for displaced state government departments. Willamette University offered 20 classrooms for that purpose. (Oregon State Library.)

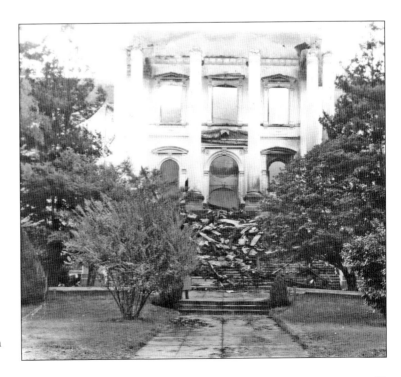

This photograph shows more of the debris that was dumped on the capitol steps. Gov. Charles Martin was in Medford when the fire happened. He canceled his trip and left at 5:00 a.m. to return to Salem, announcing that a special session of the legislature was "inevitable." (Oregon State Library.)

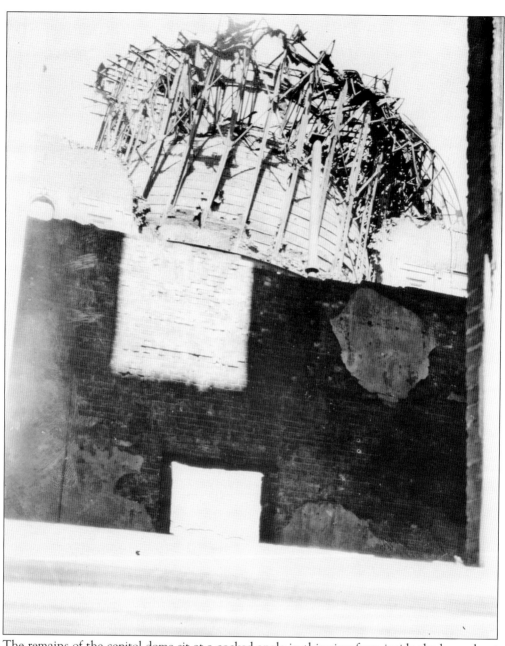

The remains of the capitol dome sit at a cocked angle in this view from inside the burned-out capitol. The day of the fire, the Oregon State Police had just completed a new personnel and noncriminal records system; it was completely destroyed. Fortunately, a system including 85,000 fingerprints of criminals was located at the penitentiary. Mei Lambert was only eight years old when she witnessed the fire. She described the dome collapsing this way in a *Statesman Journal* article: "The dome, 100 feet tall and weighing many tons, came down in a torrent of sparks. The crashing, crunching, splintering, groaning sound of the collapsing dome lasted perhaps 20 seconds. It has reverberated through my memory for 50 years." After the fire was over, officials discovered a rack of antique guns that had been rescued from the flames. It had been left unguarded, and several of the guns were missing. (Oregon State Library.)

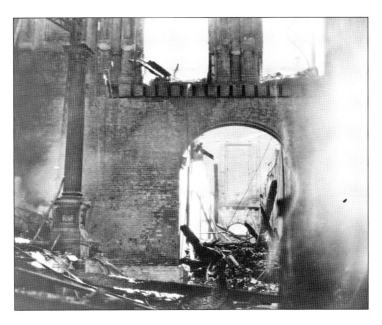

Among the wreckage inside the capitol stands a blackened column that appears to have once adorned the large lobby. In the days after the fire, a court battle between the taxpayers association and the Oregon State Board of Building Commissioners ensued over tearing down the structure. A judge even granted an injunction for a short time. Some Salem residents wanted razing to be authorized by the legislature. (Oregon State Library.)

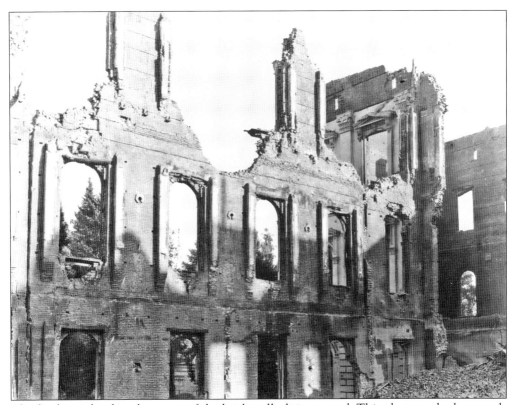

The fire burned so hot that parts of the brick walls disintegrated. This photograph also reveals piles of bricks in the lower right. Citizens managed to rescue many of the records of the secretary of state before the encroaching flames forced them out. Among the items retrieved was the original Oregon Constitution. (Oregon State Library.)

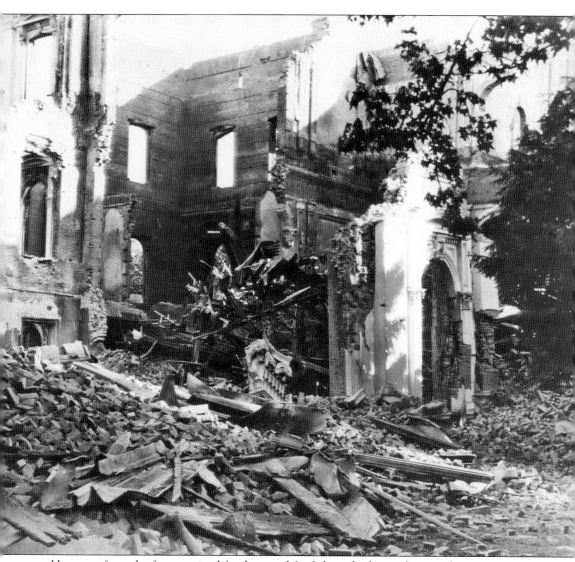

Hot spots from the fire remained for days, and firefighters had to make sure the entire structure was cool before allowing state officials inside. In this photograph are parts of a torn down wall, providing access for inspection. News accounts following the fire lamented the loss of things such as $300 worth of airmail stamps that had been purchased the day of the blaze. Percy Clark, a firefighter on duty the night of the blaze, said in a 1975 *Statesman Journal* article, "It was a water job from the beginning. Unless you had a river of water and a lot of men in the first five minutes it was a loss." Salem's water supply was plentiful, but apparently the city lacked capacity of the water mains in the area. The Oregon Washington Water Service Company owned the water system and paid for the water used by the city. Salem only paid rent on the fire hydrants. (Oregon State Library.)

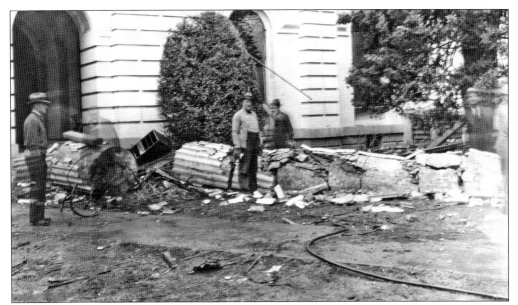

Several men appear to be clearing away debris from the capitol fire. Note the broken column across the center. Parts of these columns were put on display around Salem and on the capitol grounds. After the fire, the site became a tourist attraction for visitors from Portland and Eugene. Someone even flew in from Seattle just to see the wreckage. (Oregon State Library.)

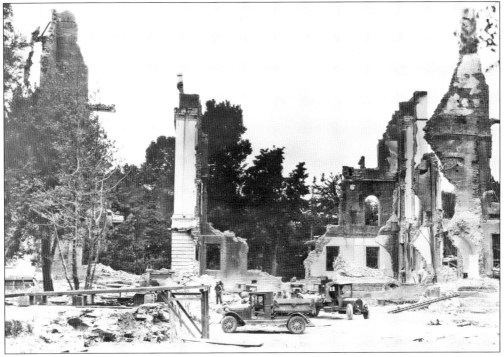

As the destroyed capitol was being dismantled, word came from Washington, DC, that Pres. Franklin D. Roosevelt would use the Depression-era Public Works Administration to aid in reconstruction. Lawmakers would need to be called into special session and decide first where a new capitol would be built. (Oregon State Library.)

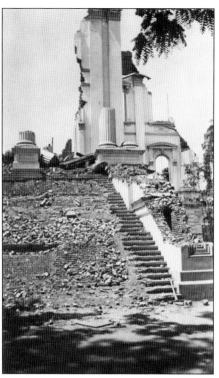

The remains of the capitol building resemble the ruins of a Roman temple as crews demolished the site. The area was very dangerous, as chimneys threatened to crash down on anyone who ventured near. A local newspaper estimated that tens of thousands came to see the aftermath of the fire. Pumps were used to siphon out an estimated eight feet of water in the basement. (Oregon State Library.)

At the end of the razing process, a lone part of the building remained. Someone placed a placard on it that read, "The Last Pinnacle Oregon State Capitol 1935." Though arson was not seriously considered, Oregon State Police did interview William Walters, who was seen hanging around the capitol prior to the fire. He had a solid alibi, so the matter was dropped. (Oregon State Library.)

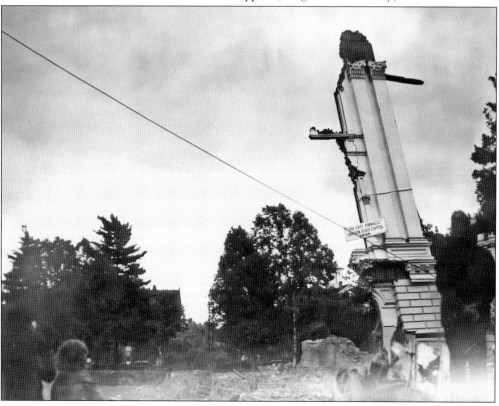

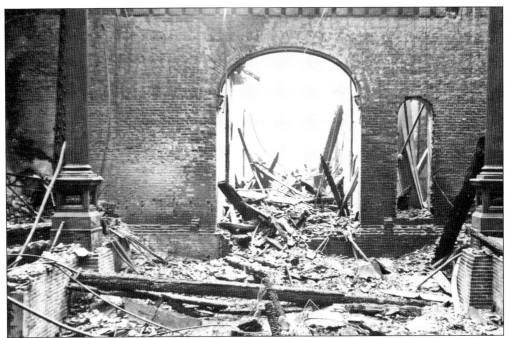

This could be the remains of one of the entrances to the capitol building. The image reveals burned timbers and brick. Fortunately, the state had recently moved about $50 million in investments out of the building and into vaults at the Ladd and Bush Bank. (Oregon State Archives.)

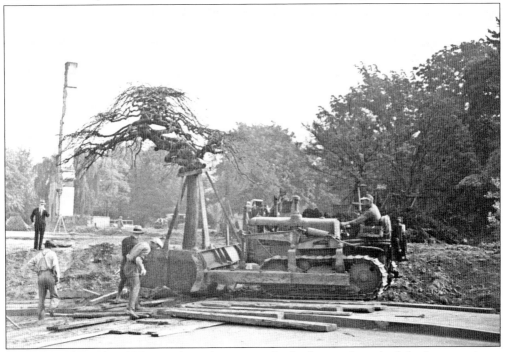

Here, ruins from the 1876 capitol can be seen in the background on the left. A crew using a bulldozer moves the Camperdown Elm tree. Many trees and bushes had to be relocated after the fire in order to make room for a different orientation of the capitol. (Salem Public Library.)

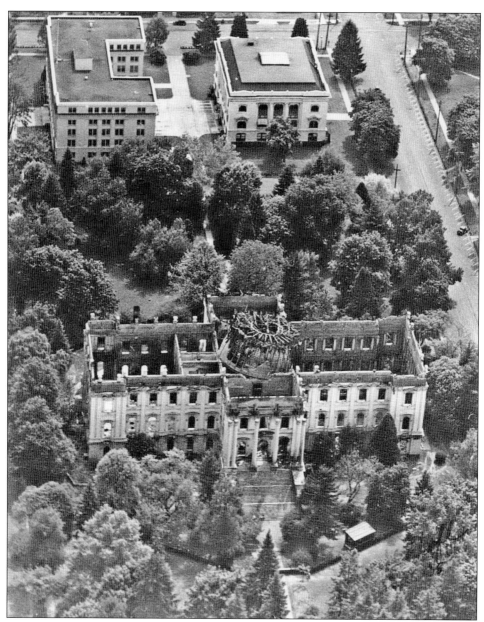

This is an aerial view of the capitol building on the day after the fire. The dome sits on the third floor, and the entire interior has been gutted. Note the Supreme Court Building to the east. In the May 1, 1935, issue of the *Oregon Statesman*, one person was quoted that the fire meant "Portland would grab the capital of Oregon." That, of course, did not happen. Soon after the fire, donations started coming in to construct a new capitol. Gov. Charles H. Martin said, "The time has arrived when the minds of our people should get off the 'gimme' idea and give rather than get." Carl E. Roseland of Roseburg responded and sent in a check for $7. Another check for $5 was received from Andrew Helmer of Grants Pass. Officials surrounded the burned-out structure with a seven-foot-tall fence. City police patrolled the site to keep visitors out. Governor Martin wanted the structure torn down as soon as possible. He said, "These walls are dangerous and should come down. We are protecting human life in razing them." (Oregon State Library.)

Four

REBUILDING

The embers had not even cooled on the destroyed 1876 Oregon Statehouse when the promise of rebuilding began. Gov. Charles H. Martin was in Medford giving a speech when the blaze occurred. He quickly canceled the rest of his trip, and upon leaving for Salem at 5:00 a.m. on April 26, he declared, "The state capitol has stood as a symbol of Oregon for more than half a century, and from the ashes shall rise a new capitol building symbolic of a new spirit and the new faith."

While state government offices were relocated to space in downtown buildings, plans for a special session and funding assistance for a third capitol by the federal government began. Pres. Franklin Roosevelt wrote to the governor, "I have requested the PWA administrator to investigate and see what assistance the federal government can render." That aid took the form of 45 percent of the cost of building a new capitol. The balance was appropriated by the Oregon Legislature in a special session between October 21 and November 9 in 1935.

A total of 123 competitors submitted designs for a new capitol building. The New York firm of Trowbridge & Livingston and Francis Keally was selected. An architect, in discussing his design, said in the July 1936 issue of *American Architect and Architecture*, "The original settlers came from New England. . . . This led me to the early Federal architecture for inspirational background." The new capitol design was Art Deco in style and labeled as a combination of Egyptian simplicity and Greek refinement.

Work on the new capitol began on December 4, 1936. The contract was held by Ross Hammond of Portland. As the building took shape, especially the cupola, more controversy erupted. In the same *American Architect and Architecture* article, people called it a "paint can" or a "squirrel cage." The designers said, "We preferred to express the dignity of the State's Capitol in the form of a monumental mass, simple as the thoughts and actions of the original settlers."

On July 2, 1938, the public got its first look inside the new capitol, and on October 1, 1938, amongst the speeches and music of the dedication ceremony, Oregon had a statehouse once again.

59

Within days of the 1876 capitol fire, the state began planning to build a new capitol. On October 23, 1935, a special session of the Oregon Legislature was held at the Marion Hotel in downtown Salem. The bill authorizing the construction took effect on November 9, 1876. (Oregon State Library.)

Charles Henry Martin served as Oregon governor during the planning and construction of Oregon's third capitol. Martin proposed reconstruction of the capitol on top of Candalaria Heights instead of on the site of the burned-out building. By the time the capitol was dedicated, Martin was a lame duck governor due mainly to his harsh antilabor stands. (Oregon State Library.)

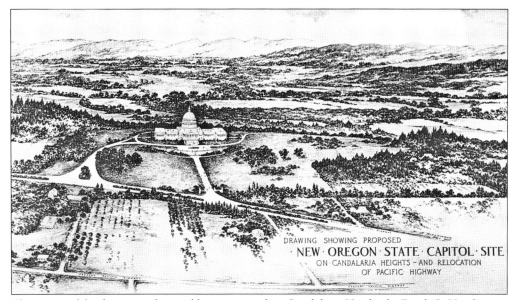

This is one of the drawings of a possible state capitol on Candalaria Heights by Frank G. Hutchinson and Harold L. Spooner. Candalaria Heights is two miles south of downtown. Gov. Charles Martin proposed purchasing a 94-acre site for $100,000. It would have had dramatic views of the Cascade and Coast Range Mountains along with the Willamette Valley. (Oregon State Library.)

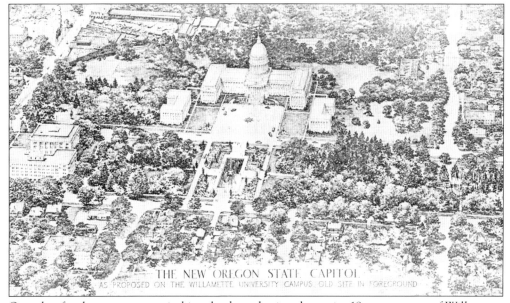

One plan for the new state capitol involved purchasing the entire 18-acre campus of Willamette University. Adding to the existing acreage would have provided 28 acres for the capitol grounds. This drawing shows a building in the classic US capitol style, facing north. Willamette University would have been moved to the current site of Bush Pasture Park. (Oregon State Library.)

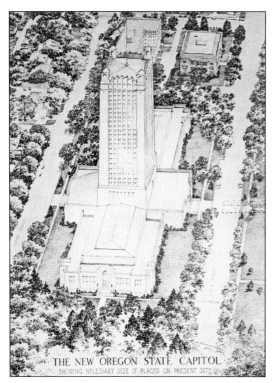

Another alternative for the new capitol on the existing site was a high-rise, as shown in this Hutchinson and Spooner drawing. Presumably, the house and senate chambers would be located on the west and east sides. This design would not have required the razing of any homes. (Oregon State Library.)

The Oregon Reconstruction League had its own idea for the replacement state capitol. In 1935, the organization proposed "A Beautiful, Modern Capitol Building" that featured a 75-foot-tall tower with 100,000 square feet of space at a total cost of $2,255,000. It was said to be "big enough to house all activities of the state government present and future." (Oregon State Library.)

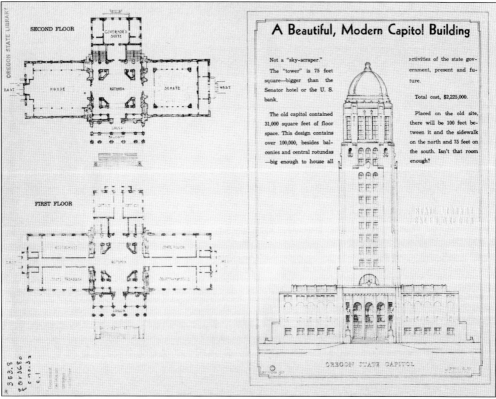

62

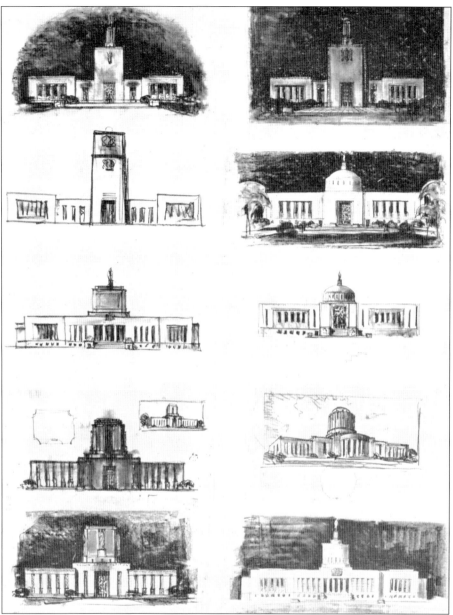

There were over 300 "rapid charcoal studies" created by the architecture firm of Trowbridge & Livingston and Francis Keally to get to the one chosen as Oregon's next state capitol design. Some envisioned tall towers, while others hoped for a modified Italian Renaissance columned entrance. Eventually, something close to the middle left idea was adopted. A total of 123 competitors submitted designs. Carl F. Gould served as the technical advisor to the Capitol Reconstruction Commission. No one knew who the jury was until all of the submissions were in place. The members were David Clark Allison from Los Angeles, Walter H. Thomas from Philadelphia, T.H. Banfield from Portland, Helen Burrell Voorhies from Medford, and E.B. MacNaughton, a Portland banker. The final design by Trowbridge & Livingston and Francis Keally purposefully eliminated the "monumental character" in order to "reduce the working elements to as compact a space as possible." (Oregon State Library.)

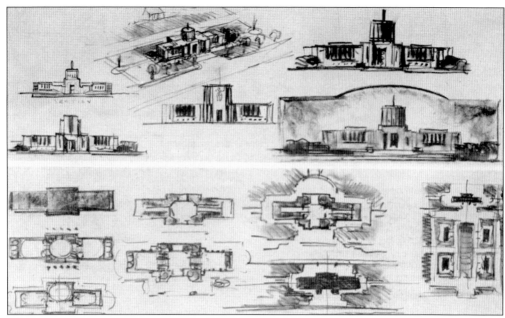

There was well over 100 submitted proposals in the competition for an architectural firm to design the new capitol. These are some of the early sketches from the winning firm of Trowbridge & Livingston and Francis Keally of New York. In these sketches, the designers were working out how the building would fit on the site. (Oregon State Library.)

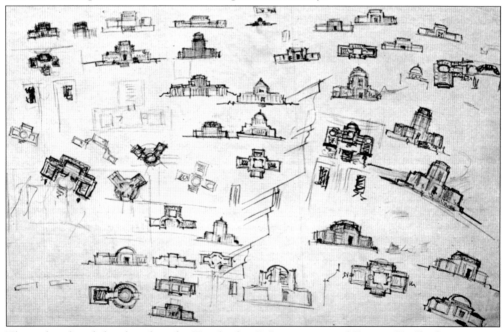

These thumbnail sketches done by Trowbridge & Livingston and Francis Keally show various possible looks for the new capitol. Some versions show a four-sided and three-sided capitol with various versions of a dome. According to the July 1936 issue of *Pencil Points*, the designers decided, "This building should have all the simplicity and fine proportion that is associated with the classic but that the detail should be related to contemporary life." (Oregon State Library.)

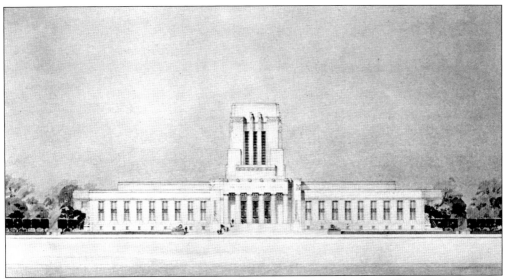

Architect W.P. Day of San Francisco, California, submitted this drawing of his idea for Oregon's state capitol building. Along with a columnar front, the design features a tall central tower, suggesting an Egyptian or even Mayan influence. Like the design chosen, this drawing features a low staircase leading up to the main entrance. (Oregon State Library.)

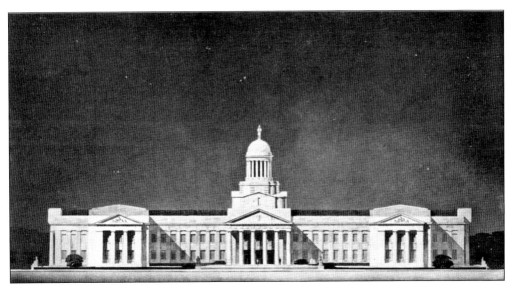

A front elevation and first-floor plan was submitted by architect Wesley Sherwood Bessell. It is reminiscent of the federal capitol featuring Corinthian columns in the front entrance, as well as the flanking house and senate chambers. Bessell was awarded $1,500 for his submission in the competition. (Oregon State Library.)

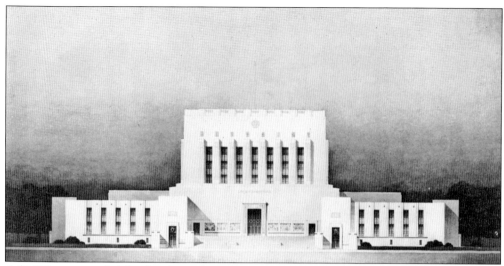

A $1,500 was awarded for this design by Walter T. Karcher and Livingston Smith. It features a very wide front staircase leading up to a central entrance, plus two smaller side entrances. The first-floor layout includes a central hall with most of the capitol taken up by senate and house chambers and offices, plus the secretary of state. (Oregon State Library.)

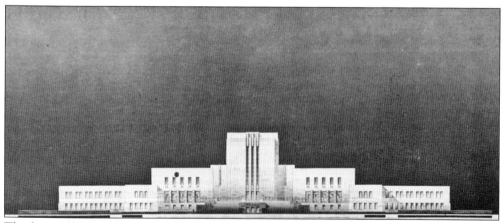

The firms of Young & Moscowitz and Carl Rosenberg Associated submitted this design for the state capitol. It has a plain exterior with no columns or statuary. The first-floor plan reveals that the building was very long and featured house and senate chambers close to the front entrance. The architects received a $1,500 award for their submission. (Oregon State Library.)

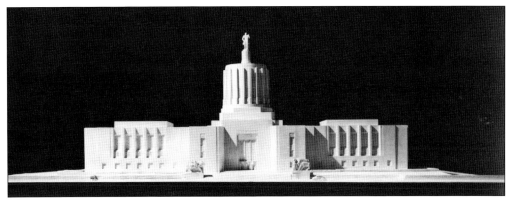

This is a model of what the new capitol would look like. The design was a combination of Egyptian simplicity and Greek refinement. Overall, it is Art Deco in style. The designers purposefully avoided a large staircase leading up to the capitol, because they felt it would discourage visitors from approaching the building. (Oregon State Archives.)

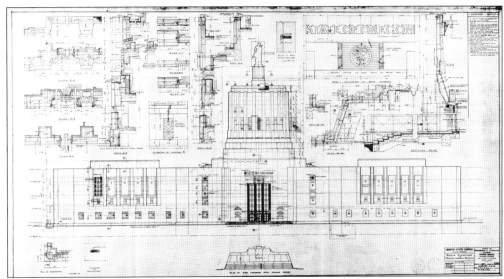

This is one of the elevation plans for the capitol construction. It shows the front of the building, details like the base of the dome, and the heights of various parts of the building. The new capitol was 164 feet wide, 400 feet long, and 166 feet tall and contained 131,750 square feet of usable space. (Oregon State Archives.)

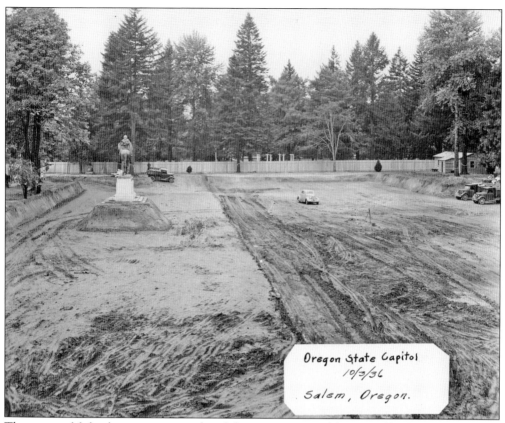

The state and federal government cataloged the construction of the capitol building by a series of photographs. This one, taken on October 3, 1936, shows excavation of the building site, a perimeter fence in the back, and several construction vehicles. The statue on the left (facing opposite the camera) is *The Circuit Rider*, which stood in front of the 1876 capitol. (Oregon State Archives.)

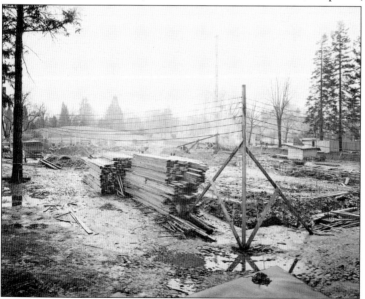

The lumber stacked at the site was most likely used to make concrete forms. Some of the forms have been raised in the background. Electricity to the site was provided by the temporary lines in the foreground. On this particular day, it appears to have snowed. (Oregon State Archives.)

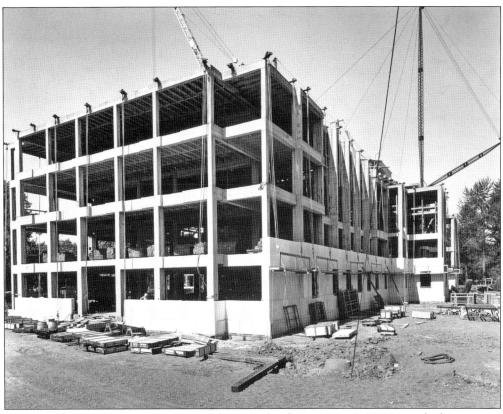

This view from the northeast corner of the capitol, taken on May 3, 1937, reveals the concrete structure of the building. Braces on the third floor are visible, as are concrete forms on the fourth floor. The crane seen in the background lifts supplies to the top floor. (Oregon State Archives.)

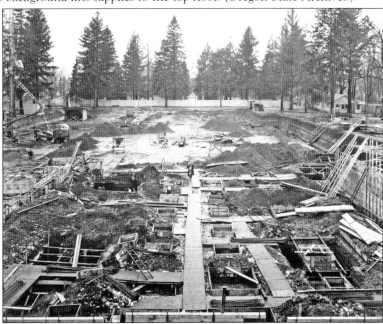

A lone worker traverses a wooden walkway across the muddy foundation of the new capitol building as work progresses. Note in this west-facing view that *The Circuit Rider* statue has been removed from the site. It stood on the left. (Oregon State Archives.)

69

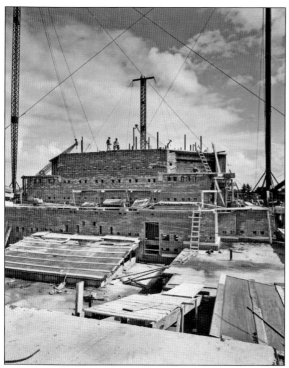

The dome of the state capitol building was constructed of brick in a ribbed lantern shape. This photograph was taken by Frank Jones of Portland on October 1, 1937, looking from the west. Francis Keally conceived and designed the dome for architects Trowbridge & Livingston. (Oregon State Archives.)

Here, the concrete form of the building begins to take shape on May 3, 1937. The view is from the northeast corner of the building. Many of these photographs were taken for the PWA, which provided 45 percent of the funding for the capitol building. (Oregon State Archives.)

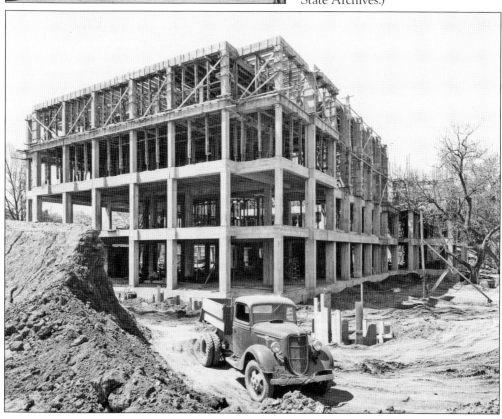

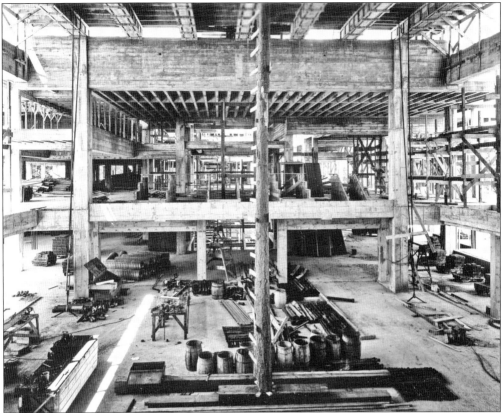

By August 2, 1937, the interior of the capitol building was still an open shell. This photograph was taken from the west looking across the center of the capitol towards the house of representatives chamber. Note the large tree trunk in the center that appears to have been used as a ladder. (Oregon State Archives.)

Items for the interior of the new capitol building were drawn before they were physically created. This photograph features a sketch of two bronze urns with images of deer, forests, mountains, Native Americans chasing buffalo, and desert scenes. The sketch was drawn by Leo Friedlander and Ulric Ellerhusen. (Oregon State Archives.)

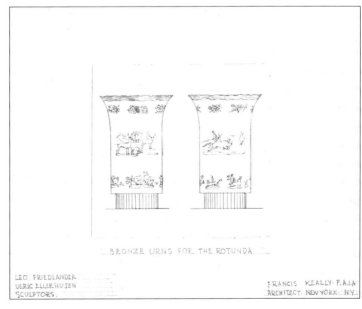

71

Ulric Ellerhusen (1879–1957) designed and created many of the sculptures that adorn the capitol building, including the *Oregon Pioneer*, which is actually bronze covered in gold leaf. This photograph was taken during his days as a student, possibly at the Art Institute of Chicago. Ellerhusen is probably best known for the 70 pieces he produced along with Lee Lawrie for the Rockefeller Chapel at the University of Chicago. A longtime member of the National Sculpture Society, Ellerhusen was an instructor throughout most of his career and based in New Jersey. He also sculpted the Oregon seal, which is set into the floor of the rotunda as one enters the capitol. In their report to the Oregon Legislature, the Capitol Reconstruction Commission said of Ellerhusen and his colleague Leo Friedlander, "These well known artists had collaborated with the Architects on their competition drawings and were recommended by the Architects for the actual commission. The excellence of the work of these artists speaks for itself." The total cost of all the murals and statuary was budgeted at $176,000. (Oregon State Archives.)

Four of the creative men behind the design and construction of the capitol building pose here in front of one of the murals. They are, from left to right, Frank H. Schwarz (muralist), Robert W. Sawyer (member of the Capitol Reconstruction Commission), Francis Keally (architect), and Barry Faulkner (muralist). (Oregon State Archives.)

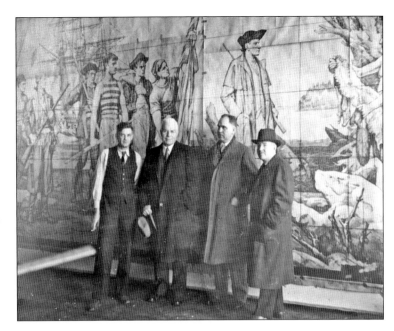

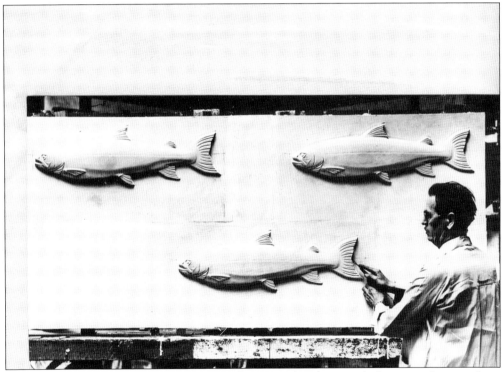

The Chinook salmon is Oregon's state fish. This particular photograph shows a sculptor working on the tail of the bottom fish. The sculpture hangs over the west entrance. In addition to Ulric Ellerhusen, Leo Friedlander also sculpted for the building. In a report to the legislature, the Capitol Reconstruction Commission stated, "The excellence of the work of these artists speaks for themselves." (Oregon State Archives.)

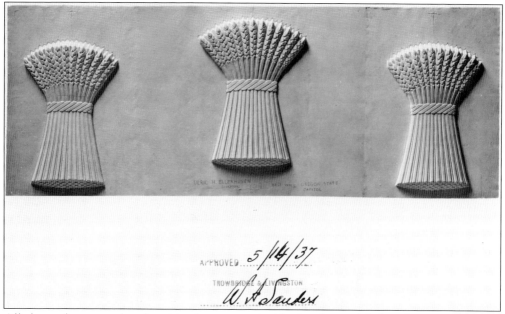

All the sculptures to be placed in the new capitol had to be modeled and approved by the architects. These wheat sheaves were sculpted by Ulric Ellerhusen to be placed above the east entrance. At the bottom, Ellerhusen wrote, "East wall Oregon State Capitol." They were approved on May 14, 1937, and signed off by W.A. Sauders on behalf of Trowbridge & Livingston. (Oregon State Archives.)

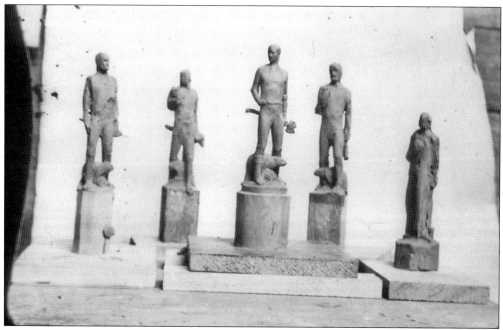

These five clay models helped the sculptor choose the right design for the *Oregon Pioneer*. Ulric Ellerhusen said his pioneer carried a splitting axe in one hand and a tarp draped over his shoulder and faced west with the intention to build a shelter from cut wood and the tarp. (Oregon State Legislature.)

This wooden frame of an early model of the *Oregon Pioneer* sits in the New Jersey studio of Ulric Ellerhusen. Ellerhusen most likely placed it in front of a white backdrop in order to see what it might look like against the sky. The sculpture is known as *Oregon Pioneer*, "Gold Man," or "Golden Pioneer." (Oregon State Legislature.)

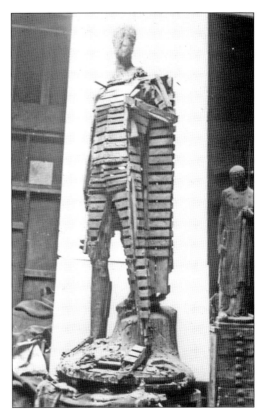

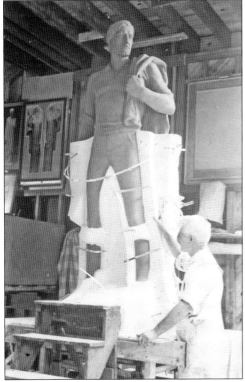

This photograph appears to show a casting of one of the many models made of the *Oregon Pioneer* before Ellerhusen created the final version. Other works of art can also be seen on Ellerhusen's studio walls. The sculptor was well known for many architectural works of art at other capitols, such as those in Nebraska and Louisiana. (Oregon State Legislature.)

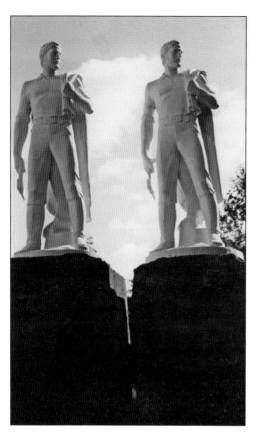

The sculptors created several models of what became the *Golden Pioneer*. Here, two models were set up outside and photographed against the sky. They appear to be fairly large-scale models. The photograph is dated September 16, 1937, and was signed as approved for Trowbridge & Livingston by K.S. Barr. (Oregon State Archives.)

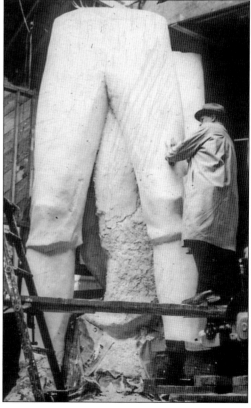

It is easy to see the scale of the *Oregon Pioneer* statue as a sculptor stands on scaffolding just to reach the knees. The pioneer was designed to "exemplify the spirit of Oregon's early settlers who went west in search of a better or more adventurous life." At 22 feet tall, it easily dwarfs its maker. (Oregon State Legislature.)

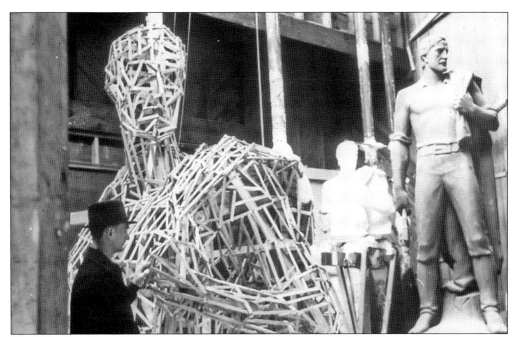

To create the head of the *Oregon Pioneer*, sculptors made models of various sizes, which can be seen to the right. A worker then attached a series of small plates of an unknown composition until a cast could be made over the top. (Oregon State Legislature.)

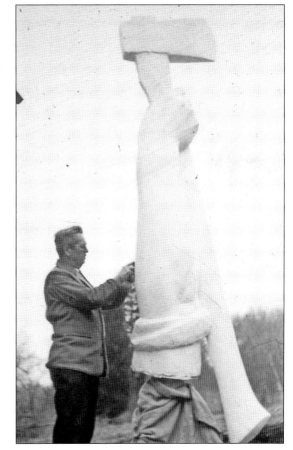

A sculptor works on the single-bitted axe that the *Oregon Pioneer* holds in his right hand. Ulric Ellerhusen created the sculpture in his New Jersey studio, but as seen here, Ellerhusen had to move it outside. He had a large door built into the studio in order to move outdoors and see the sculpture in natural light. (Oregon State Legislature.)

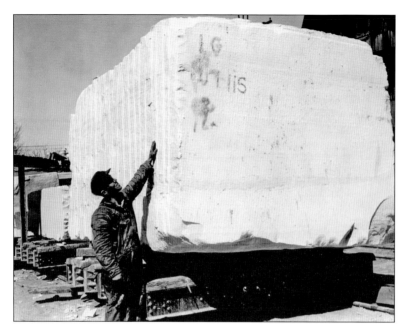

A worker places his hand on one of the giant blocks of white Danby Vermont marble after its removal from the quarry. The marble was cut into 4- to 12-inch widths. Marble absorbs very little water, and the designers of the capitol considered this when choosing a material with which to face the capitol. (Oregon State Archives.)

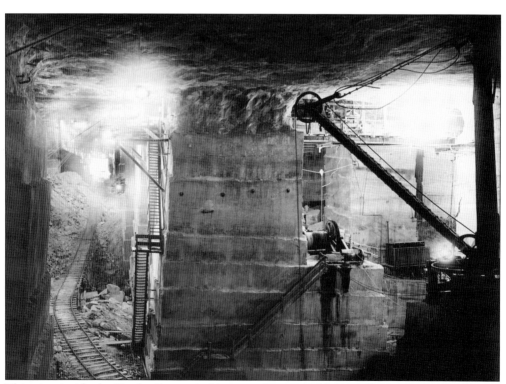

This view inside the Danby Quarry in Vermont shows a rail line used to transport marble cut from the formation, a stairway, and various cranes used to move the extremely heavy pieces onto the railcars. The Danby Quarry is the largest underground quarry in the world. (Oregon State Archives.)

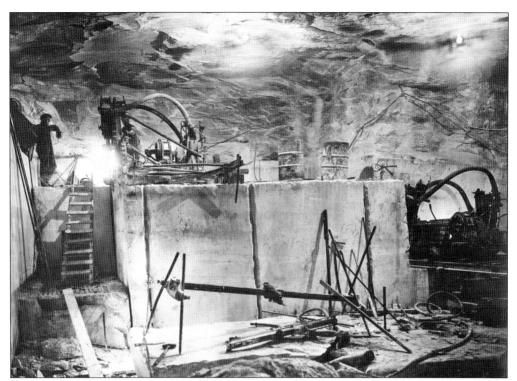

In this photograph, a quarry worker (left) observes another worker running a piece of machinery that cuts large slabs of marble from the mine. It appears that the machine is a large band saw that can cut 12-foot blocks of marble at a time. Various saw bits sit next to the marble in the lower part of the frame. (Oregon State Archives.)

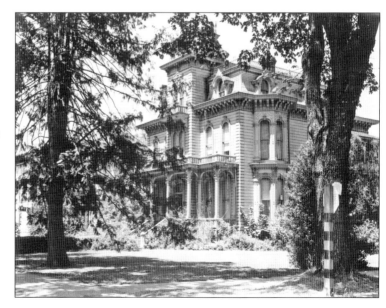

Part of the new capitol building project included land for other government buildings. In 1937, the legislature authorized spending $300,000 for land around the capitol. Edith Louise Patton could not agree with the state on a price, and the matter went to court. A jury awarded her $45,600. (Oregon State Archives.)

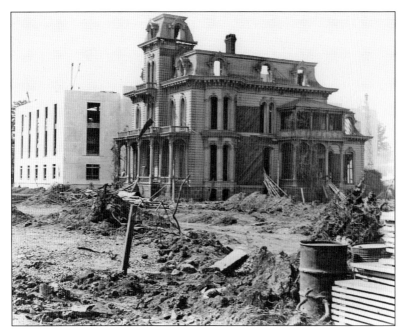

The Cooke-Patton House was built between 1868 and 1870 by Edwin N. Cooke when he was state treasurer. It stood just to the north of the capitol building across the street at the site of the current state library and was torn down to make room for the new library structure. (Oregon State Library.)

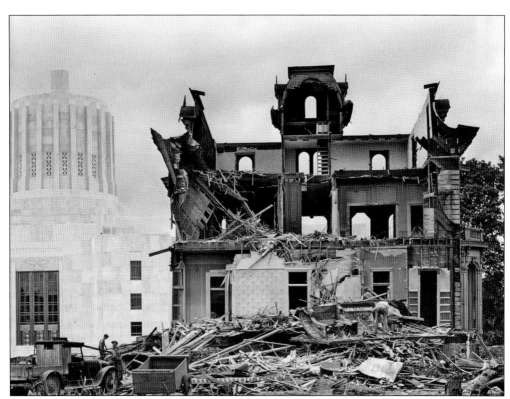

This photograph features a rare look into the Cooke-Patton House as it was being demolished. Visible is the wallpaper on a downstairs wall, along with the ladder that led up to the Victorian-era central tower. Two men load rubble into a pickup truck to the left of the house. (Salem Public Library.)

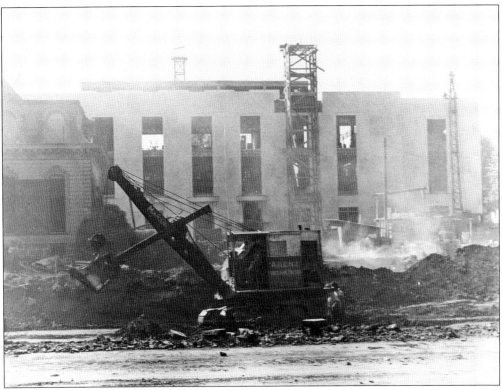

The Cooke-Patton House appears as nothing but a pile of rubble after crews have finished demolishing it. A steam shovel from Arenz Construction helps remove the debris from around the property as two construction workers walk alongside. Dust from the house kicks up in the background. (Oregon State Archives.)

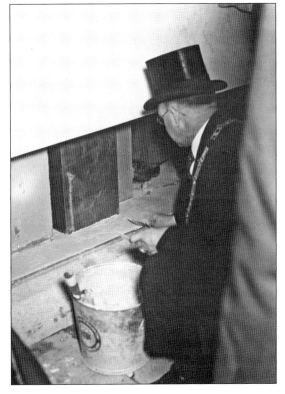

As part of a special ceremony on June 17, 1937, Frank Peters, grand master of the Lodge of Ancient and Accepted Free Masons, laid the cornerstone of the new capitol building. Among the items placed in the cornerstone were a current copy of the *Oregonian* newspaper, a replica of the 1876 capitol, and an 1849 one-cent coin. (Salem Public Library.)

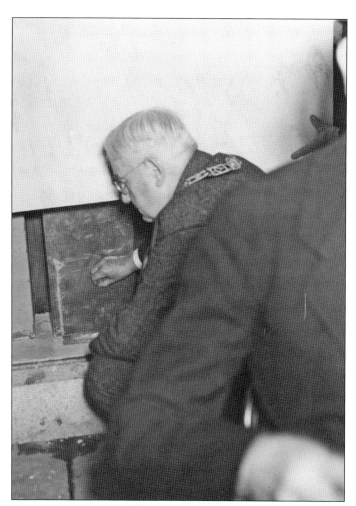

An unidentified man, perhaps another Mason, inspects the cornerstone of the capitol. Other items placed in the box were a copy of the *Oregon Democrat* newspaper, an 1837 dime, and relics from the old capitol, including a piece of wood, a small piece of lead from a window, and a piece of the copper dome. (Salem Public Library.)

A group of unidentified women pose behind the cornerstone of the capitol before it was put into place. Among the other items placed into a box in the cornerstone were a state seal, a list of articles in the cornerstone of the 1876 capitol, and a selection of foreign coins from countries such as Finland, the Kingdom of Hawaii, England, and South Africa. (Oregon State Library.)

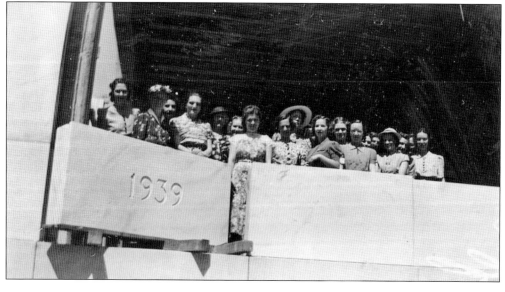

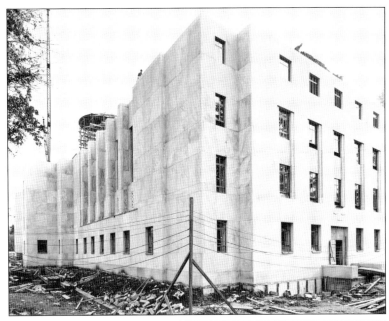

This photograph was part of a series taken on November 2, 1937, from the northeast corner. In the background is the scaffolding of the dome under construction. By this time, windows had also been installed. Workers can be seen on top of the structure peering over the edge. (Oregon State Archives.)

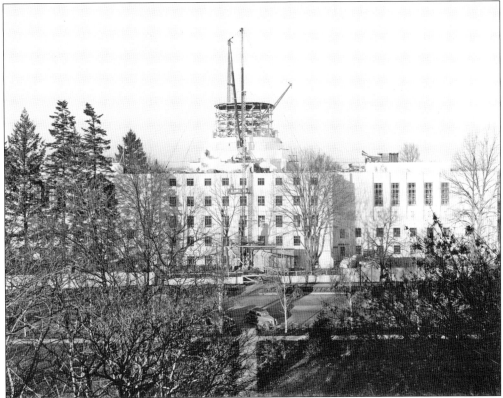

On December 1, 1937, the dome atop the capitol begins to take shape, built over a steel framework and overlaid with marble. This particular view looks to the north from the campus of Willamette University across State Street, which was a two-way street at the time. (Oregon State Archives.)

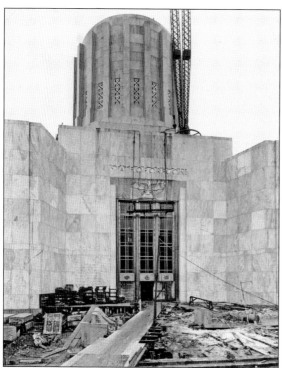

Here, the dome appears nearly complete from a view of the front. A lot of construction debris remains on what will be the staircase, and a long wooden walkway serves as the only way into the building. Pieces of marble lie in front waiting to be installed. (Oregon State Archives.)

This is how the Oregon State Senate chamber appeared before the opening of the state capitol on October 1, 1938. The paneling and furniture was made entirely of golden oak. Above the galleries of both chambers are friezes containing the names of 158 people prominent in the history and development of Oregon as a state. (Oregon State Archives.)

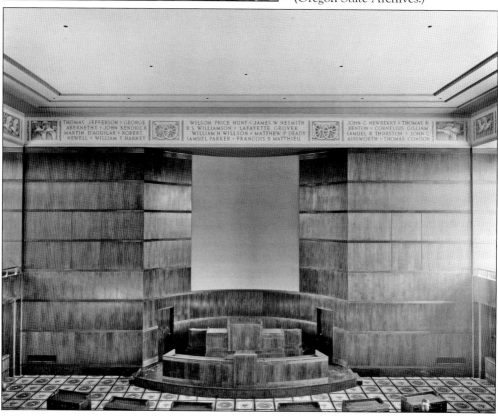

This plaque was installed to commemorate the capitol building project. It gives the number of the federal project (OREG 1031-1-R), the state authorization for the project, and the names of the governor, president of the senate, speaker of the house, members of the capitol commission, and the architects and builders. (Oregon State Archives.)

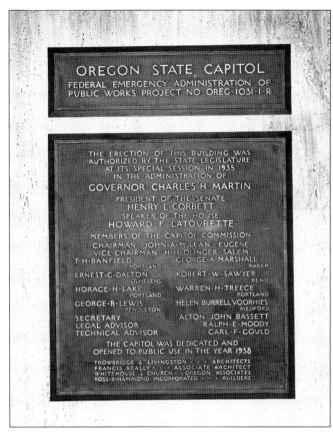

The *Oregon Pioneer* arrived in Salem on board a truck and encased in a wooden frame. It had travelled on a ship through the Panama Canal and by railcar on its way to Oregon. The 22-foot-tall statue was clad in gold leaf after it was installed. (Oregon State Legislature.)

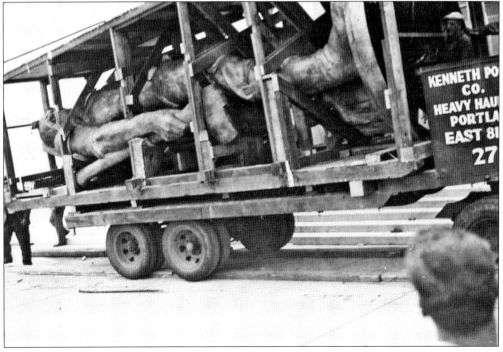

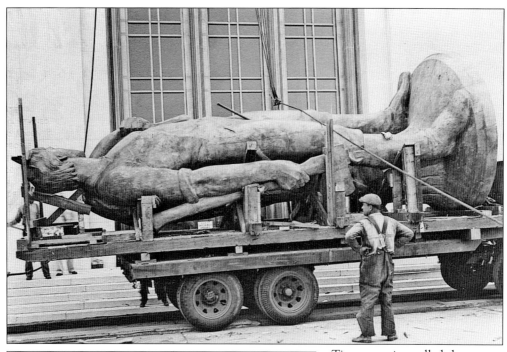

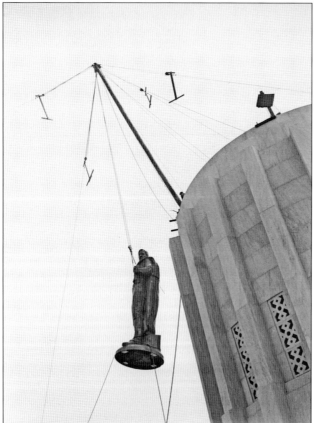

Time magazine called the *Oregon Pioneer* statue "the brawny woodsman." After removing the top of the wooden frame, workers attached heavy-duty cables to lift the bronze man 106 feet into the air. The man in the foreground (with arms at his side) appears to be studying what to do with the Ellerhusen creation. (Oregon State Library.)

The installation of the *Oregon Pioneer* began on September 17, 1938, just two weeks prior to the dedication ceremony. The installation took several days and had to be suspended briefly for the contractor to find heavier-duty cranes to lift the statue to the top of the dome. (Oregon State Library.)

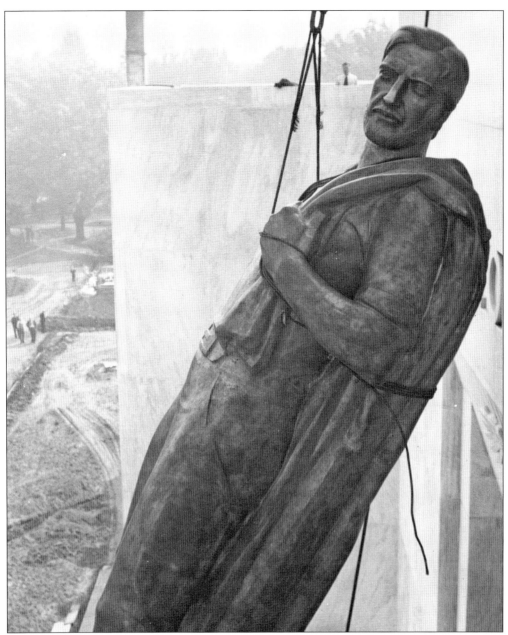

The *Oregon Pioneer* rests just above the front entrance to the capitol on its way to the stand on top of the dome. The sculpture almost appears to be holding onto the cables. Note that none of the entrances to the new building have been finished at this time. A man in the background watches the procedure. When the capitol opened a few weeks later, most were not aware of the many changes to the plans after the initial contracts were signed. In a report to the Capitol Reconstruction Commission in January 1939, the firm overseeing the project (Whitehouse & Church) stated that accusations that the architects misunderstood the grade levels of Court and State Streets were untrue: "On the contrary, they deliberately used this clever scheme to gain [an] extra lighted floor." The company also added additional entrances on the east and west ends of the capitol. (Oregon State Archives.)

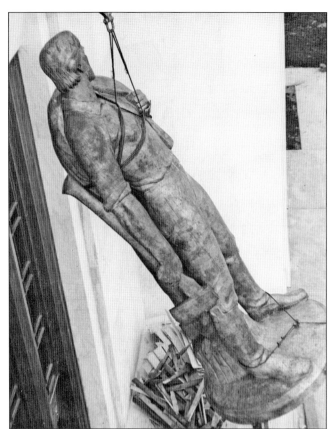

The *Oregon Pioneer* pauses on its way atop the capitol building. The bronze statue weighs eight-and-a-half tons and is covered in gold leaf. During the 1993 "Spring Break Quake," the *Golden Pioneer* actually bounced on its platform and had to literally be glued back in place. (Oregon State Archives.)

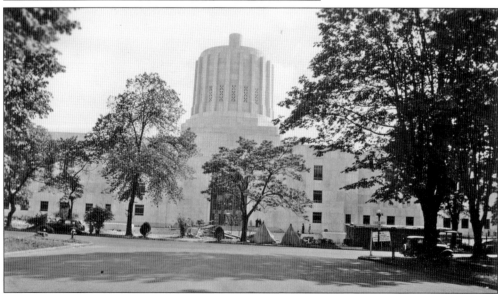

This photograph of the nearly complete Oregon State Capitol was taken prior to September 1938, because the *Oregon Pioneer* statue has not yet been installed. Construction equipment sits in front of the building. Note that the photographer is standing on a street. Later, Summer Street was closed to create a pedestrian-only capitol mall. (Oregon State Library.)

Five

A New Capitol

With the official passing of the keys to the new state capitol, a workforce of about 2,000 occupied a building of 131,750 square feet. The original cost estimate for the capitol was $3.5 million, but the Oregon Legislature only appropriated $2.5 million, so committee rooms were removed from the plans. The Art Deco–style capitol is the fourth newest in the United States. It measured 164 feet in width, 400 feet in length, and 166 feet in height in 1938.

Thousands gathered to be the first to step foot in the new building. Men took their hats off in respect as they entered the rotunda. Gov. Charles H. Martin remarked that the capitol "stands as proof that cooperation and teamwork are the only ways to achieve a goal satisfactory both from the physical and esthetic standpoints."

Though the building's interior appeared to some as fairly Spartan, attempts were made to "warm up" the place. One promotional book produced at the time stated, "The warmth of the beautiful travertine marble used throughout the main portions of the building offsets any touch of coldness in design."

Leslie W. Scott, president of the Portland Chamber of Commerce, said in an October 2, 1938, *Oregon Statesman* article: "This new state house is more than of stone and mortar; rather it is of spirit, containing emblems of hundreds of years of mankind's strivings westward. These streamlined walls, surmounted by a pioneer, symbolize American trends that are significant of new world progress. This great house marks a goal of individualism, of local self-government."

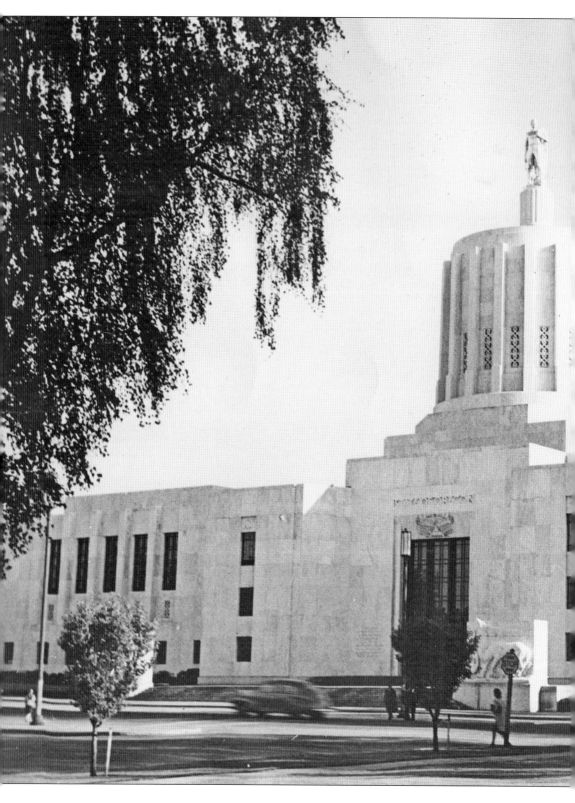

Three and a half years after the burning of the capitol, Oregon finally had a new building to house state government. The construction cost $2.5 million. It is the fourth-newest capitol in the United States and is 164 feet wide, 400 feet long, and 166 feet tall. Leslie W. Scott, president of the Portland Chamber of Commerce, said of the new capitol in an October 2, 1938, *Oregon Statesman* article, "Our people catch the spirit [of western progress] in the dramatic spectacles at Eugene, Pendleton, Astoria and elsewhere. They see here the typical western state of the American commonwealth. They fix their eyes today upon this scene, this capitol dedication, emblem of the great march westward. Our Oregon is a monument to American expansion and this scene, a crowning pageant." (Oregon State Library.)

91

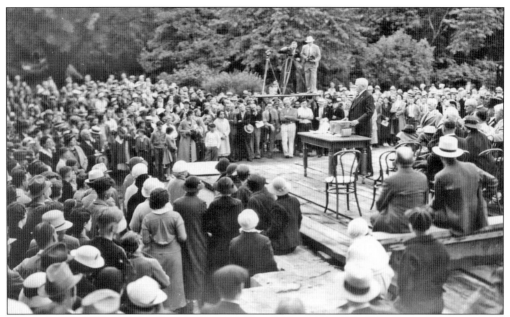

Oregon governor Charles H. Martin addresses the crowd gathered at the dedication of the new capitol on October 1, 1938. Note the photographers perched on scaffolding above the onlookers. Following the dedication ceremony, Governor Martin held a reception inside. (Oregon State Library.)

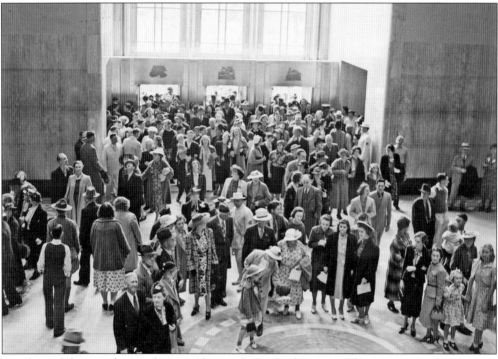

Members of the crowd enter the capitol rotunda for the first time. The event took place on July 2, 1938, a few months prior to the dedication ceremony. At this time, several items remained unfinished, including gilding the *Oregon Pioneer* statue, which was completed on October 25, 1938. (Salem Public Library.)

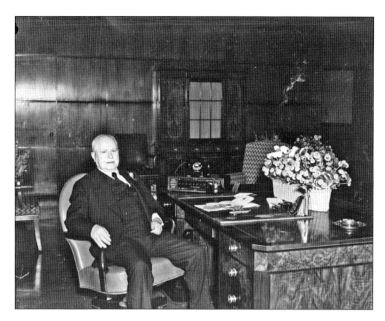

Gov. Charles H. Martin sits at a brand-new desk in his office in the new capitol building. This photograph was taken on July 2, 1938. The governor has flowers on his desk, as well as a telephone and some sort of intercom device. Martin had only a few months to enjoy this office. His antilabor stance most likely cost him the Democratic nomination for reelection. (Salem Public Library.)

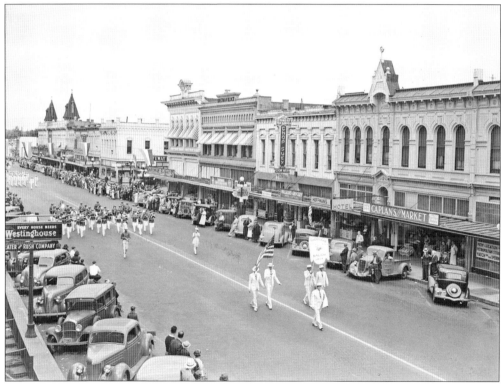

On the day the capitol first opened for viewing on July 2, 1938, the Cherrians held a parade in downtown Salem to celebrate. In this image, they walk on Commercial Street dressed in their typical white suits. They pass a Safeway store, the Chinese Tea Garden, Walker's Grocery, and Caplan's Market. A partial company name on the left indicates they sold Westinghouse merchandise. (Salem Public Library.)

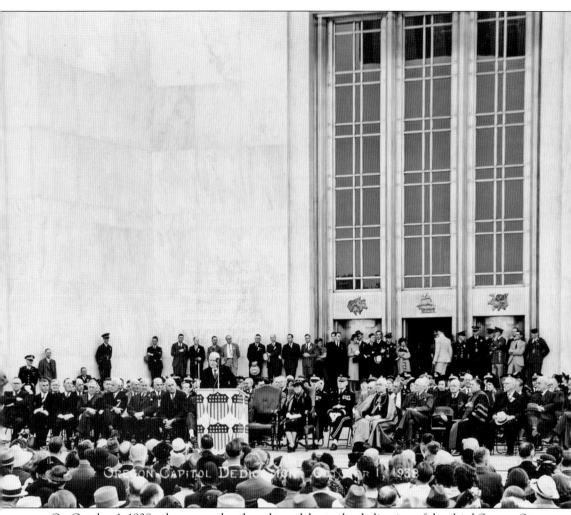

On October 1, 1938, a large crowd gathered to celebrate the dedication of the third Oregon State Capitol building. Here, Gov. Charles H. Martin makes his remarks in front of dignitaries. The program included an invocation by the Episcopal Bishop of Oregon and the song "America" by the Willamette University Glee Club. As a sign of the times, Martin spent much time in his speech talking about the less tangible elements of society: "Too much emphasis has been placed on materialism in our immediate past. We are now paying the penalty for neglecting our spiritual development; for our failure to raise it to the same high plane that our material progress has reached. In this sense we must not only rededicate ourselves to the restoration of the spiritual factors so necessary for the well being of a people, but actually work—and work unceasingly—to that end." (Oregon State Archives.)

John A. McLean (right), chairman of the Capitol Reconstruction Commission, speaks to the crowd on dedication day. The man on the left is unidentified. McLean presented the building for occupancy. In a report to the legislature, McLean wrote, "The design and plans which they worked out have produced a building which we feel will take its place among the distinguished Capitols of the Nation." (Oregon State Legislature.)

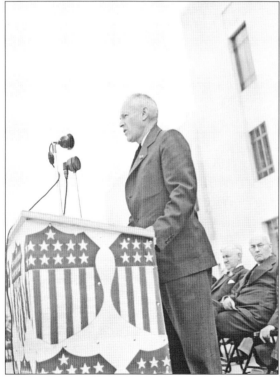

It is most likely that the man in this photograph is C.C. Hockley, state engineer for Oregon of the federal Public Works Administration. The PWA paid for 45 percent of the cost of the capitol out of the New Deal programs created during the Great Depression. Hockley was on the dedication program right after the invocation. (Salem Public Library.)

Leslie Scott, president of the Portland Chamber of Commerce and chair of the Capitol Reconstruction Commission, stands at the podium and delivers the dedication address for the new capitol on October 1, 1938. He said, "This great house marks a goal of individualism, of local self-government." (Salem Public Library.)

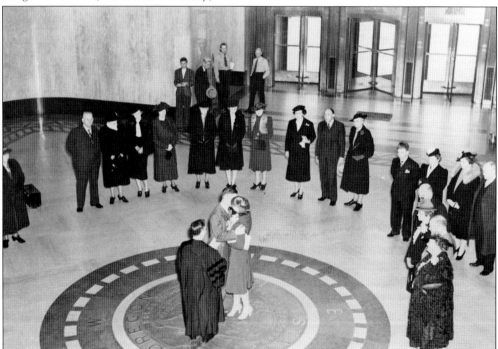

In April 1939, the first wedding was held in the rotunda of the recently opened state capitol building. The unidentified couple and their minister stand in the in the middle of the state seal in the center of the rotunda. Family and friends stand in a circle surrounding the couple as witnesses to the ceremony. (Salem Public Library.)

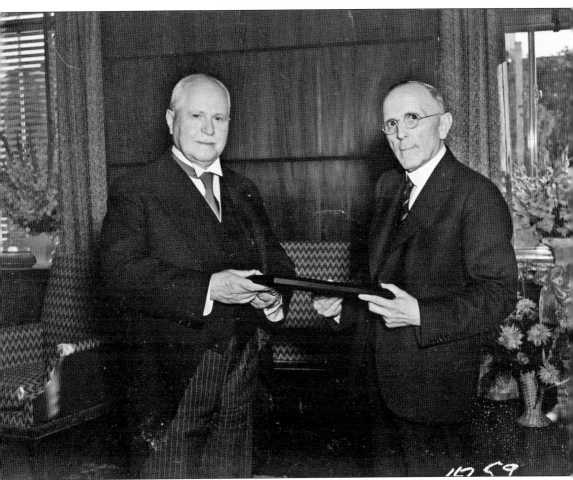

Gov. Charles H. Martin receives the keys to the new capitol from John A. McLean (right), chairman of the Capitol Reconstruction Commission. This happened during the dedication ceremony on October 1, 1938. Martin is quoted as saying, "Well done," about the efforts to construct the house for state government. "I can only echo the words in the hearts of all of us—the capitol commission, the architects, the contractors, the draftsmen—well done!" Martin went on to turn his speech into a comment on the current global war: "We have been smug in the belief that so long as we pay our taxes the machinery of government will continue. That is the most dangerous state of lethargy into which we can sink. It is the beginning of the end, for I warn you that if continued it will mean that the forces of evil and darkness will commandeer the sinews you provide, not for the furtherance of good government and betterment of democracy, but for their own corrupt programs of destruction and ruin." (Salem Public Library.)

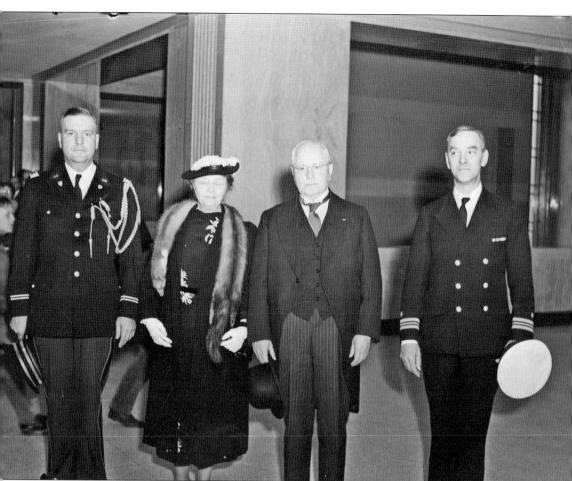

Gov. Charles H. Martin (second from right) stands with his wife, Louise, between two military aids just outside of the governor's new offices on the second floor of the capitol building. During his speech, Martin said, "The building speaks for itself; it tells the story of a brilliant conception, harmonious execution and faith in the future." Martin's time in office was marked with much controversy. He was elected governor in 1934 during a time of intense labor unrest and in the middle of the Great Depression. He oversaw the construction of the Bonneville Dam and the creation of statewide port and highway infrastructure. He became known as a pro-business governor, though a Democrat. During a strike in Columbia County, Martin is said to have threatened to fire the Columbia County sheriff if he did not "beat hell out of 'em [striking workers]." Martin's open criticism of Pres. Franklin Roosevelt's New Deal probably cost him the Democratic nomination for a second term as governor. (Salem Public Library.)

This view of the capitol grounds looks north towards Chemeketa Street. The stakes in the ground for newly poured sidewalks makes up for the lack of landscaping. The landscaping contract was given to Northwest Landscape & Nursery Company. It specified that it lay 15,790 feet of copper pipe for the lawn sprinklers. (Source Oregon State Library.)

This view looks north of the capitol towards Winter and Chemeketa Streets. In a report to the legislature, the Capitol Reconstruction Commission stated it had problems getting the sprinklers and landscaping done on time. The work was under the auspices of the landscape division of the state highway department. (Oregon State Library.)

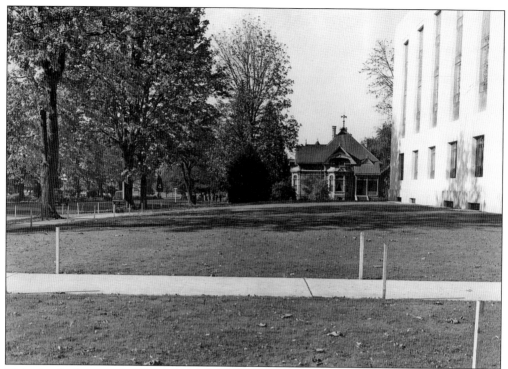

This view looks towards Winter Street from the south side of the capitol. Court Street is on the left. Many of the homes in the capitol mall area were later torn down to make room for the capitol grounds and for more state buildings in the capitol mall area. (Oregon State Library.)

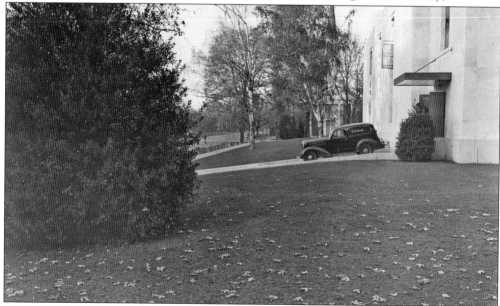

The west side of the state capitol building along Winter Street shows the loading dock. A black vehicle, labeled "U.S. Mail," is parked at the top of the driveway leading to the loading dock. Though this photograph was taken in 1939, the sidewalks and landscaping are still not complete. (Oregon State Library.)

One of the final touches to the new state capitol was the raising of two wooden flagpoles in front of the building on December 6, 1940. The two 75-foot-tall poles were mounted in bronze sleeves set in granite bases and tipped with bronze. The contractor who built the poles was E.E. Settergren from Portland. (Salem Public Library.)

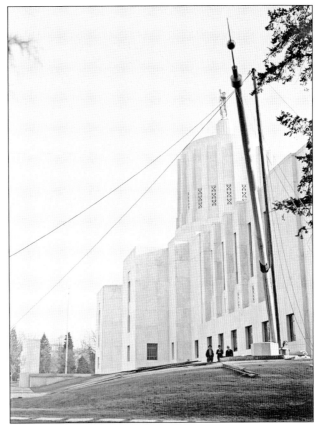

Turned towards the crowd, the camera captures the large number of people who turned out for the laying of the cornerstone of the capitol building. Though the crowd's specific size was unknown, aerial photographs show that it filled the entire northeastern section near the capitol. (Salem Public Library.)

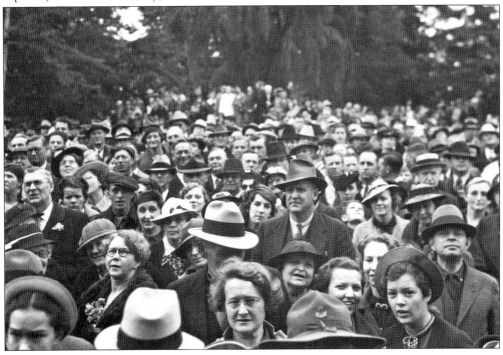

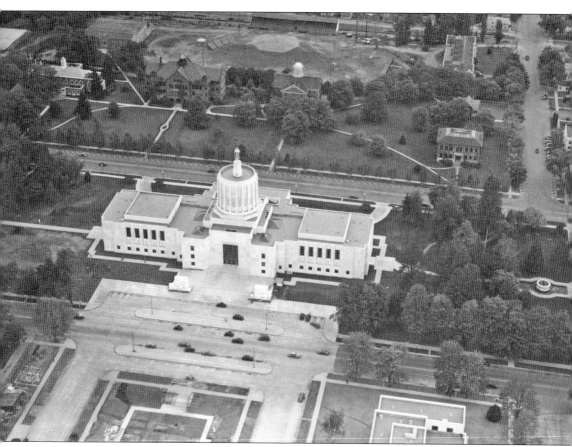

Shortly after opening, this aerial photograph was taken of the brand-new capitol building and Willson and Capitol Parks. The state departments that moved into the new building included the governor, secretary of state, state police, property control, board of control, budget department, press, license division, motor vehicle division, state treasurer, land board, inheritance tax, state auditors, state banking department, capitol commission, insurance department, state highway commission, and the liquor control commission, as well as both the senate and house of representatives. After the opening, much work still had to be completed on the building and surrounding areas. Court Street had to be reconstructed, altering the grade for 1,000 feet, and was repaved with concrete, creating sidewalks and safety islands and a driveway in front of the capitol. (Salem Public Library.)

Six

WILLSON PARK

In 1853, William H. Willson, a prominent Salem pioneer, sold a plot of land to the territorial government for the construction of a statehouse. This land, known as Block 84, was a three-block-long open stretch of land approximately 300 feet by 1,100 feet bounded by Court, Church, State, and Capitol Streets. It was renamed Willson Avenue. After the original statehouse was finished, Willson Avenue was again renamed Willson Park. The park was just an open grassy meadow. By 1870, a whiteboard fence had been installed mainly to keep out stray animals.

Originally, the park contained a simple, narrow north-south walkway from Church Street to the entrance of the capitol. Alexander James Miller helped construct Oregon's second capitol building in 1873. Miller planned and planted Willson Park, designing a series of circular walkways with trees like ash and weeping willow. The Breyman Fountain was added near Cottage Street in 1904, along with a gazebo.

At this time, Willson Park was owned by the City of Salem. When the 1876 capitol building burned in 1935, more land was acquired to increase the size of the capitol and other state buildings. George Otten, the state highway department landscape engineer, drew up landscaping plans for the new capitol mall. Otten chose native shrubs, such as rhododendron and the state flower, the Oregon Grape. He also planted native conifers such as Douglas fir, spruce, red cedar, and maple.

The 1962 Columbus Day Storm destroyed much of Willson Park, so it was redesigned, rebuilt, and replanted under a contract with Lloyd Bond & Associates. The firm created a central grass oval walkway and replaced the original Waite Fountain with a low pool and fountain. Today, one of the main features of Willson Park is the "Walk of Flags" around that central oval. Willson Park is now owned by the state as a state park. The areas on the west and east of the capitol building are actually two parks today. Willson Park stands on the west, and Capitol Park is on the east.

William Willson created a plat for the city of Salem, and most of the city's major institutions are located within his property. Part of the land along Willson Avenue was for a state capitol, and the rest was deeded to the City of Salem in 1853 as a city park. (Salem Public Library.)

Alexander James Miller made the first plantings in Willson Park and also helped build the 1876 capitol building. Miller was born in 1829 in Greene County, New York. In 1864, he immigrated to Oregon with his family in a wagon train with over 100 wagons. Miller died in Yamhill County in 1915. (Oregon State Library.)

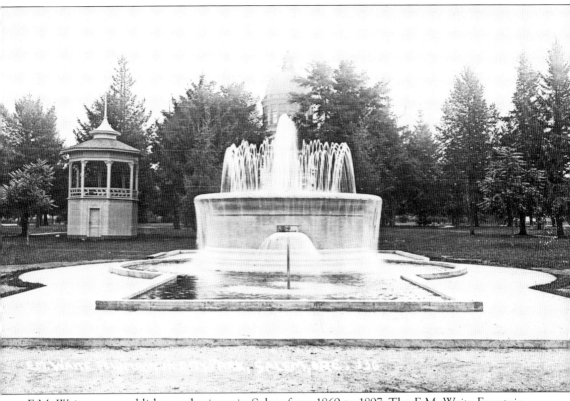

E.M. Waite was a publisher and printer in Salem from 1869 to 1897. The E.M. Waite Fountain was completed in 1912 after Louise Waite left the city $10,000 for the fountain. She did it in honor of her husband who collapsed and died while marching with a group of printers in a parade. E.M. Waite published Salem's first city directory in 1871. The City of Salem agreed to protect the fountain with a jail sentence or fine for anyone damaging it. In the early 1960s, the state took control of Willson Park from the city and planned to demolish the fountain. Controversy arose over the protection ordinance. It stood in the center of Willson Park until 1965, when the Salem City Council offered to build a new fountain if the city could tear down the old one. (Salem Public Library.)

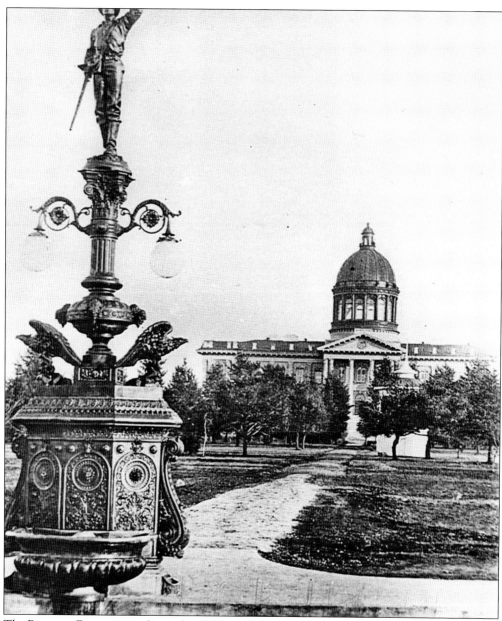

The Breyman Fountain was located in Willson Park near Cottage Street. This photograph shows the fountain with the 1876 capitol building in the background. It was placed here in 1904 and is the only remaining historical object from this period in the park's history. It was a gift to the city of Salem by Werner Breyman, a well-known businessman. Note how the water collects at the bottom of the sculpture. Because of this, it became known as "Breyman Horse Trough." The fountain can be seen from either of the Breyman brothers' homes on State and Court Streets. The doughboy on top of the fountain was replaced in the 1950s with an eagle, and where horses once drank, flowers grew. A descendant of the Breyman family is quoted as saying that the ornaments on top were taken down and melted for scrap metal during World War II. (Oregon State Library.)

This is a photograph of an original sketch by Alexander James Miller. It shows a plan for circular walkways traversing Willson Park and transforming a simple walkway into a destination park. All the plant locations are marked in pencil. Miller called for flowers, trees, and plants such as tulips, marigolds, ash, maple, weeping willow, and laurel. (Oregon State Library.)

The 1876 state capitol building, pictured prior to 1890 when the dome was added, shows a number of young plantings. The park began as nothing more than a cow pasture but developed slowly into a large circular and "X"-pattern walk. It was filled with dozens of coniferous and deciduous trees. (Salem Public Library.)

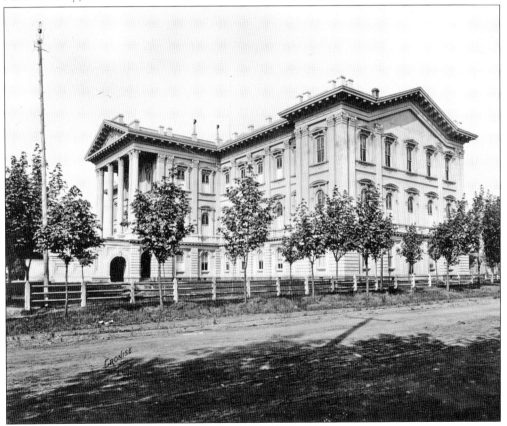

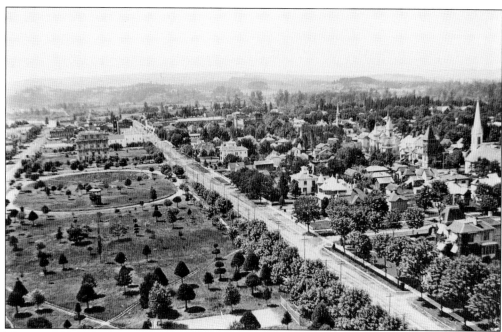

This view from the 1876 capitol dome looking west was photographed sometime between 1894 and 1897. At this time, a circular walk had been installed around a central gazebo. In the far background is the old Marion County Courthouse. The beginnings of other walkways can be seen in the center foreground. (Salem Public Library.)

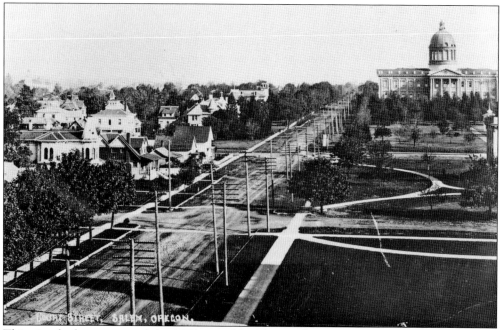

This view looks east toward the 1876 capitol building and across Willson Park, which features some maturing trees. The photograph was taken after 1890 but before Court Street (on the left) was paved. A corner of the old Marion County Courthouse can be seen on the far right. (Salem Public Library.)

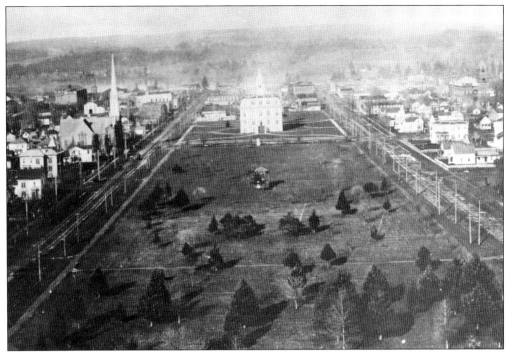

Here is an 1890 image taken from the dome of the 1876 capitol building. Looking to the west, the Marion County Courthouse sits in the center background. Willson Park is surrounded on the south by State Street and the north by Court Street. Both streets appear to be dirt tracks. Only very young trees are growing in the park at this time. (Salem Public Library.)

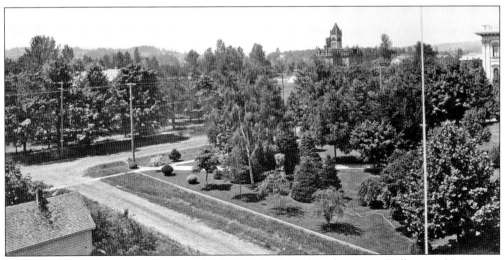

William Willson donated the land for the Oregon Institute, later known as Willamette University. This photograph, taken from Willamette University, is of the southwest corner of Willson Park with the second capitol building in the background. Most of the plantings in the park were destroyed in the Columbus Day Storm of 1962. (Oregon State Library.)

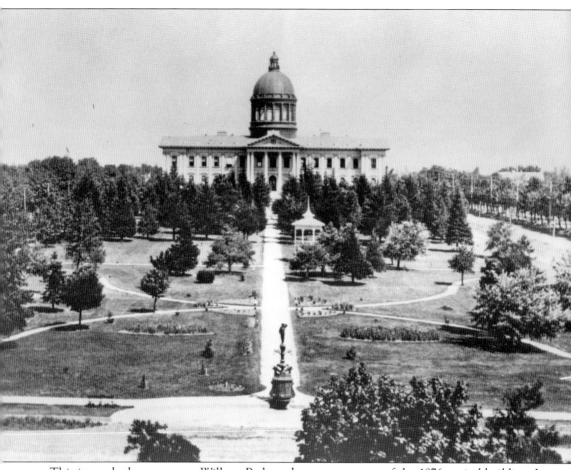

This image looks east across Willson Park to the west entrance of the 1876 capitol building. In addition to Breyman Fountain, a gazebo and bandstand are visible. On the right edge are a horse-drinking trough and the new Cottage Street Tram going down State Street. Though much of the vegetation in the park is sparse, plans called for varying marigolds and tulips in the small central flower garden in the center of the frame. Poplars were to grow where the Breyman Fountain stands. Linden bushes were to be scattered throughout the park, as were maple trees. Between the capitol fire of 1935 and the 1962 Columbus Day Storm, not much of the original vegetation remains; however, the Breyman Fountain (minus the doughboy) survives. A portion of the park was listed in the National Register of Historic Places in 1988. (Oregon State Legislature.)

Seven

PLANS AND
MODERN BUILDING

Providing space for a growing state government is never complete. During the years following the completion of the capitol in 1938, the Capitol Planning Commission has considered numerous ideas for reshaping the capitol itself and the capitol mall.

An undated plan, presumably from the 1950s, suggested a massive expansion to the mall without changing the capitol building itself. The mall would stretch north to D Street. Another plan called for such a large expansion that the nearby high school and junior high would be demolished, and the mall could extend all the way to the Willamette River. None of these plans were adopted, though the mall area and state agency buildings do extend from the capitol to D Street today.

Adequate legislative offices and committee rooms were left out of the original capitol building due to budget constraints. The capitol wings project in 1976–1977 added 189,199 square feet to the capitol. The project was the first to benefit from a 1975 law that required one percent of all state building construction or renovation to be set aside for visual art. Thus, a collection of about 150 works of art, including 69 photographs spanning the 20th century, was installed.

Age and natural disasters have also affected the capitol. Three times, the *Oregon Pioneer* statue has had to be regilded with gold. During the 1980s, schoolchildren saved up their pennies to help fund the effort. In 1993, the "Spring Break Quake" damaged the capitol and caused the statue to bounce on his pedestal. During the building's 75th-anniversary year, legislative leaders considered spending $250 million on the capitol, installing special "base isolators," which are essentially big shock absorbers under the building, so that it could withstand a major earthquake.

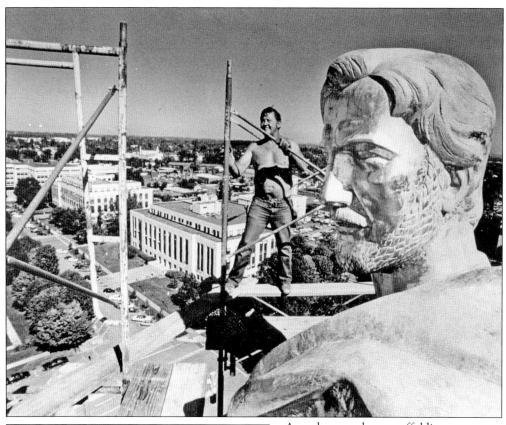

A worker stands on scaffolding surrounding the *Oregon Pioneer* statue during the 1980s. Though the statue is made of bronze, it was gilded with 24-karat gold leaf. Because of weather, it had to be regilded in 1958, again in 1984 (at a cost of $36,000), and finally in 2000. That regilding was performed by Pete McKearnan and Lee Littlewood of Portland. (Salem Public Library.)

This aerial photograph was taken sometime between 1971 and 1973. The capitol building can be seen in the far background without the legislative assembly wings or the underground parking lot. In the center foreground is the initial construction of the Employment Department Building, which was completed in 1974. (Oregon State Archives.)

In 1958, a vision for the capitol mall was created for the capitol planning board. This is a model of that vision. Note the capitol itself (upper center), various new buildings in the blocks north (never built), and an auditorium (incorporated into the Employment Department Building). (Oregon State Archives.)

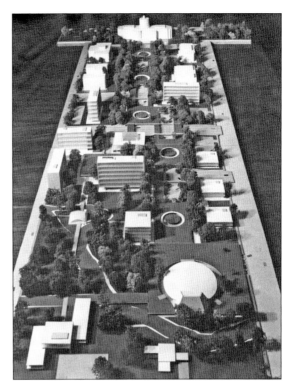

A pedestrian bridge was part of the never-adopted 1958 capitol mall plan. These bridges were to cross Marion and Center Streets. This plan eventually called for the mall to expand beyond a local junior high and high school, all the way west to the Willamette River. The model was created by Wilmsen & Endicott of Eugene. (Oregon State Archives.)

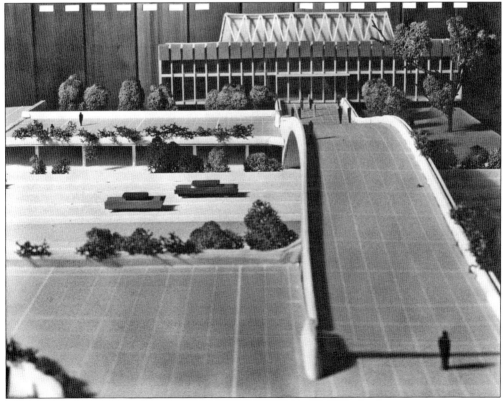

113

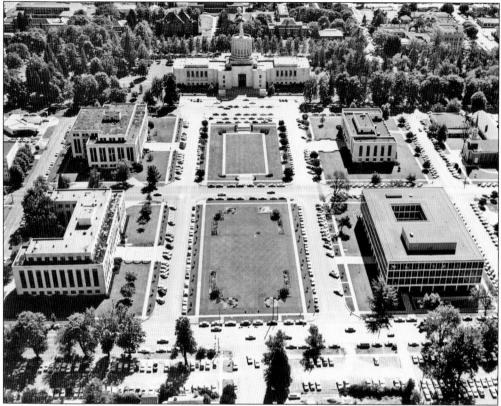

This aerial view shows the capitol building and mall as it looked in the early 1970s. Note that the entire mall area is open for traffic and parking. The four buildings north of the capitol are the state library (upper right), labor and industries (lower right), department of transportation (lower left), and public service (upper left). (Oregon State Archives.)

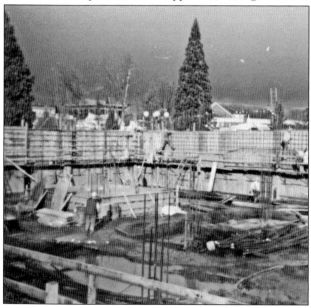

In 1977, the Oregon State Legislature completed work on the 1938 capitol by adding committee rooms, legislative offices, and a first-floor galleria. The two wings added to the side of the capitol cost $12.5 million. This photograph shows the forms for concrete footings and walls, as well as the steel reinforcing rods in the west walls. (Oregon State Archives.)

A total of 26 mature trees had to be dug up and replanted to make way for the 1977 addition of wings to the state capitol building. Among the trees was an autumn cherry, which was moved to another site on the capitol grounds. (Oregon State Archives.)

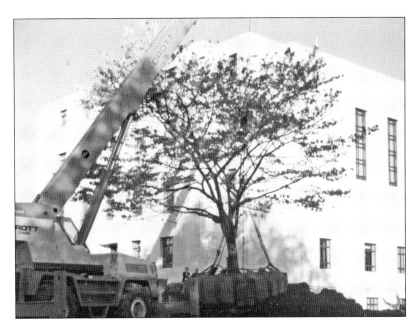

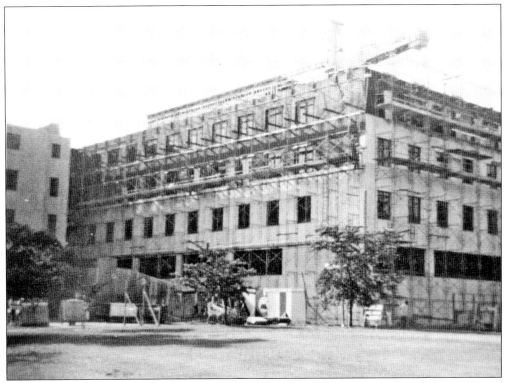

By August 11, 1976, workers were installing marble facing on the north face of the west wing of the expansion. The project effectively doubled the square footage in the capitol building. The building's additional construction continued, even though its financing scheme was ruled unconstitutional by the Oregon Supreme Court. (Oregon State Archives.)

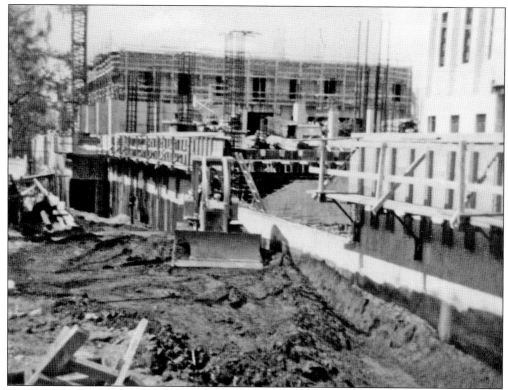

On April 21, 1976, a TD-7 bulldozer backfills sand against the south wall of the new capitol wing expansion. Once completed, the expansion was furnished at a cost of over $645,000. A committee of two Republican and two Democratic legislators picked out the furniture. About $89,000 was spent on artwork, and $122,000 went to a closed-circuit television system. (Oregon State Archives.)

On February 10, 1976, a worker drills into an existing wall to put in a new main fire pipe. Once open, there was controversy about the color scheme of the carpet, but eventually visitors and staff seemed satisfied, according to Frances Bell, head of the capitol guide program, who said, "People find it a lot easier to find their legislator." (Oregon State Archives.)

This is a September 1, 1977, view of the east wing and terraces. These gardens were added outside of the governor's offices and are not accessible to the general public. The legislative wing can be seen in the background on the right. (Oregon State Archives.)

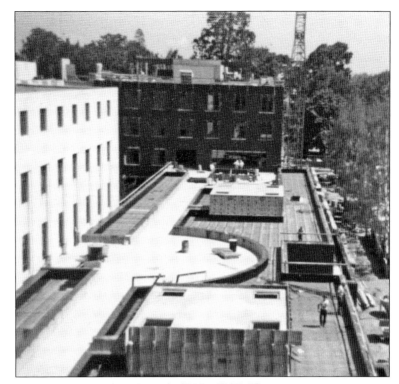

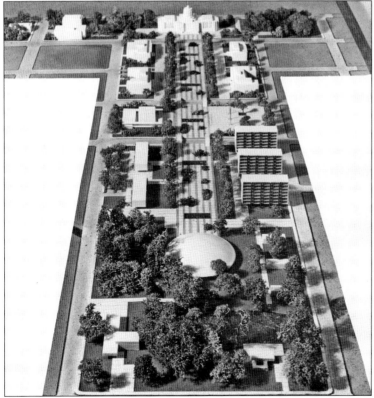

Over the years, many plans and models have been created for the capitol mall. This undated model was created prior to the expansion of the capitol in the 1970s and features three high-rise office buildings along a central walkway and an auditorium on the north side of the mall, a repeated feature eventually built into a mall structure. (Oregon State Archives.)

Oregon's capitol building turned 50 in 1988. A celebration took place on the capitol grounds, including the cutting of this special cake. Seated in front of the cake is state historian Cecil Edwards. Standing above Edwards is Oregon Gov. Neil Goldschmidt (wearing the hat). Other events planned for the October 1, 1988, celebration included three performances of *Up in Oregon*, a play about Oregon history. (Oregon State Archives.)

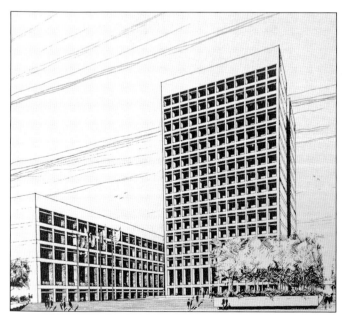

In a 1971 report, the Capitol Planning Commission continued to fight with space needs of a growing state government. This drawing is a conceptual design for a "Multi-storied office building" that would be built on the capitol mall. This design is reminiscent of early designs for the state capitol, but this recommendation was never acted on. (Oregon State Archives.)

Eight

CAPITOL EVENTS

The Oregon State Capitol has been no stranger to natural disaster. The first two capitol buildings were destroyed by fire, and fire could have destroyed the third capitol had it not been for a fast-thinking student at Willamette University who saw smoke in the early morning of August 30, 2008. Fortunately, the fire was extinguished quickly.

Other natural disasters have not been as kind. On October 12, 1962, a storm that ranked among the most powerful extratropical cyclones ever in US history struck Oregon. Winds of up to 179 miles per hour were recorded. In Salem, 90-mile-per-hour winds rushed through town and the capitol mall. The storm ruined Willson Park and toppled at least one statue to the ground.

Other events in the capitol's history include the visits of Presidents William Howard Taft (in 1911) and Dwight D. Eisenhower (in 1952), as well as then Vice Pres. Richard M. Nixon (in 1959). Oregon's military presence was also celebrated at the capitol, including artillery pieces that were put on display and fired and a visit by the first regiment of the Oregon National Guard to see action in war.

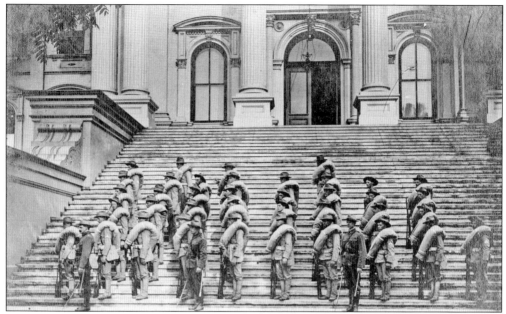

This photograph was likely taken in 1898 of the 2nd Regiment, Oregon Volunteer Infantry. The 40 unidentified men stand at attention on the steps of the 1876 capitol before deploying to San Francisco to take part in the Spanish-American War. This was the first time that members of the Oregon National Guard had fought on foreign soil, and it was at the request of Pres. William McKinley. (Oregon State Library.)

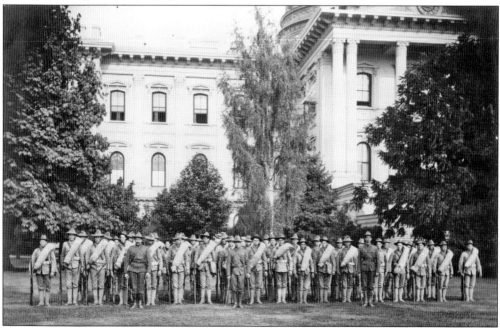

This appears to be the entire 2nd Regiment posing at the ready on the grounds of the 1876 capitol prior to deployment. This regiment took part in the peaceful surrender of Guam and was the first US Army unit to land on the Philippines as well as enter the walled city of Manila. Sixteen members of the unit were killed in action. (Salem Public Library.)

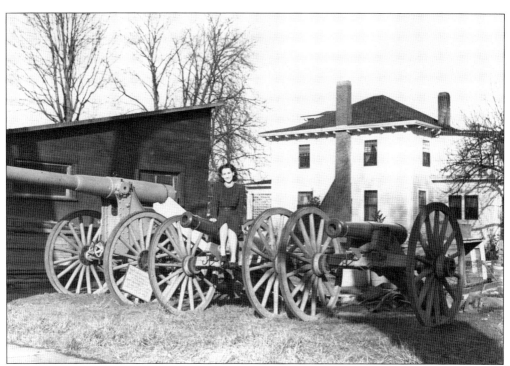

Pictured in January 1940, an unidentified woman sits on one of three artillery pieces displayed on the grounds of the state capitol. This occurred shortly before the United States entered World War II, but the purpose of the display is unclear. A cannon was also displayed on the grounds of the 1876 capitol. (Salem Public Library.)

On January 13, 1941, Frank Millet, commander of the Veterans of Foreign Wars (VFW) Marion Post No. 661, and H.H. Sim, senior vice commander, raise the American flag in front of the capitol building. The Marion post of the VFW was founded on March 16, 1931, on Hood Street NE. (Salem Public Library.)

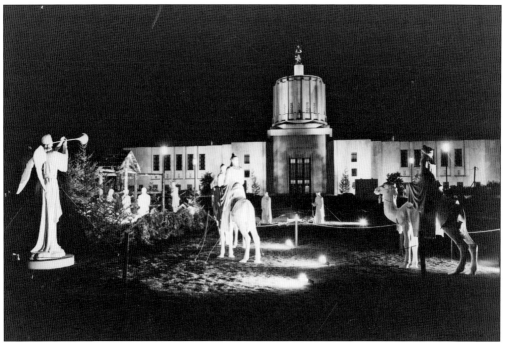

This is the last time a nativity scene appeared on the capitol mall. Taken in 1960, the photograph shows life-size figures thought to have been created by Oregon prison inmates. The capitol itself is also lit up for the season. A controversy arose over this religious display on public property, and it was later moved across the street to Willamette University. (Salem Public Library.)

This view of the damage to Willson Park caused by the Columbus Day Storm was taken in the southwest corner of the park and shows some of the uprooted trees. The building in the background is the First Presbyterian Church, which is located on North Winter Street. (Salem Public Library.)

In the aftermath of the Columbus Day Storm, workers clean up fallen trees by cutting them up and hauling them away. This photograph was taken on the northwest portion of Willson Park. The state capitol building stands in the center background with the Public Service Building to the left. (Salem Public Library.)

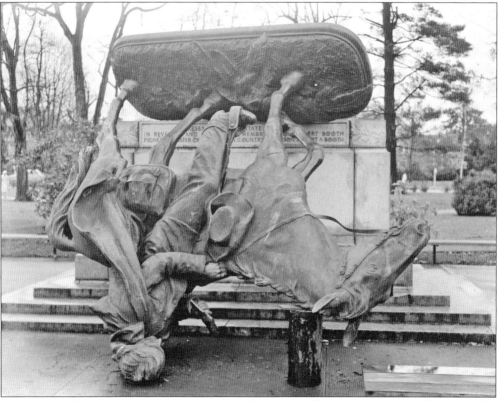

After the 1962 Columbus Day Storm, workers discovered that a spruce tree had knocked the *Circuit Rider* statue off of its marble perch and split it at the seams, causing much damage. The statue's head and shoulders required repair, so the statue was moved away from the capitol grounds for a time. (Salem Public Library.)

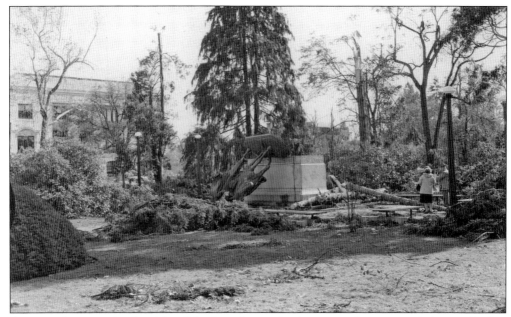

A man and woman (to the right of the frame) view the damage to the state capitol grounds after the Columbus Day Storm. Many of the bushes and trees in Willson Park were uprooted and had to be replaced. The damaged *Circuit Rider*'s head and shoulders are hidden behind some of the debris. (Salem Public Library.)

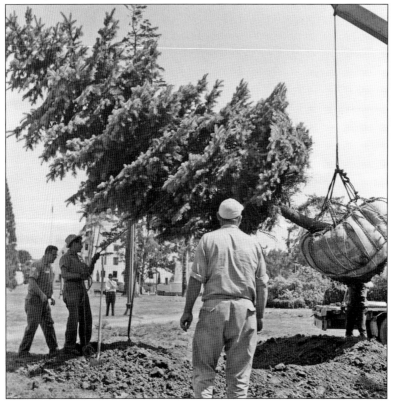

On October 12, 1962, peak winds of 90 miles per hour ripped through Salem during the Columbus Day Storm. In August 1963, crews are seen replanting a large conifer as part of the replanting project. The capitol building is in the background. The building shielded Capitol Park to the east from extensive damage. (Salem Public Library.)

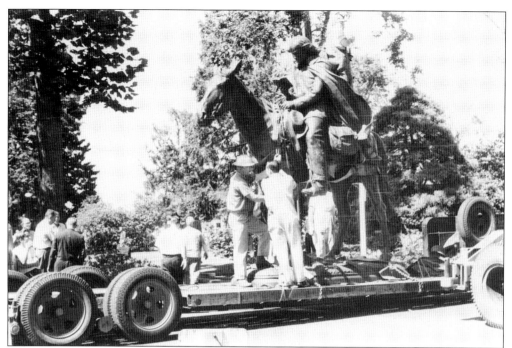

The *Circuit Rider* statue returns to the capitol grounds after the Columbus Day Storm on the back of a flatbed truck. The statue, created by A. Phimister Proctor and commissioned by Eugene businessman Robert A. Booth, stood in front of the 1876 capitol facing west. It was removed during construction of the new building. (Salem Public Library.)

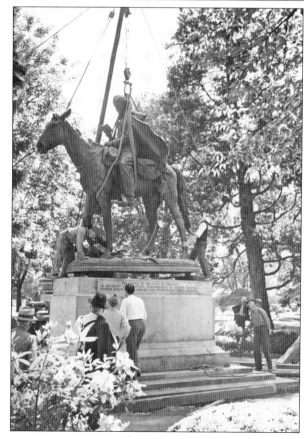

Workers gently place the *Circuit Rider* statue on a platform. It was made of bronze and originally installed in 1923, only 11 years before the 1876 capitol burned. The words below the statue commemorate the state's early evangelists, who often rode between churches. (Salem Public Library.)

A capitol building administrator enters the offices of the governor. A sign on the side of the door reads, "No public access." Early on the morning of August 30, 2008, construction materials on a second-floor terrace caught fire, damaging these offices, plus several others, and causing the governor to relocate to the state library. (Photograph by author.)

Smoke, fire, and water damage are evident inside the governor's ceremonial office after the 2008 fire. The blaze was discovered by a Willamette University student who lived across the street. Though it was put out in just 20 minutes, the fire damaged committee rooms and the legislative counsel library. (Photograph by author.)

BIBLIOGRAPHY

Bentson, William Allen. *Historic Capitols of Oregon: An Illustrated Chronology.* Salem, OR: Oregon Library Foundation, 1987.

General Park Plan 2010. Salem, OR: Oregon Parks Department, 2010.

Horner, John B. *Oregon, Her History, Her Great Men, Her Literature.* Portland, OR: J.K. Gill Company, 1919.

Oregon State Capitol Competition. New York: The American Architect, July 1936.

Report of the State Capitol Building Commissioners of the State of Oregon. Salem, OR: State of Oregon, 1874.

Report of the State Capitol Reconstruction Commission. Salem, OR: State of Oregon, 1937.

Report of the State Capitol Reconstruction Commission. Salem, OR: State of Oregon, 1939.

State Capitol Souvenir Book. Salem, OR: The Statesman Publishing Company, 1938.

Stein, Harry H. *Salem: A Pictorial History of Oregon's Capital.* Norfolk, VA: The Donning Company, 1981.

Thomas, Walter H. *The Oregon State Capitol Competition.* East Stroudsburg, PA: Reinhold, 1936.

Discover Thousands of Local History Books
Featuring Millions of Vintage Images

Arcadia Publishing, the leading local history publisher in the United States, is committed to making history accessible and meaningful through publishing books that celebrate and preserve the heritage of America's people and places.

Find more books like this at
www.arcadiapublishing.com

Search for your hometown history, your old stomping grounds, and even your favorite sports team.

Consistent with our mission to preserve history on a local level, this book was printed in South Carolina on American-made paper and manufactured entirely in the United States. Products carrying the accredited Forest Stewardship Council (FSC) label are printed on 100 percent FSC-certified paper.